P9-AQJ-789

EVERY PICTURE TELLS A STORY

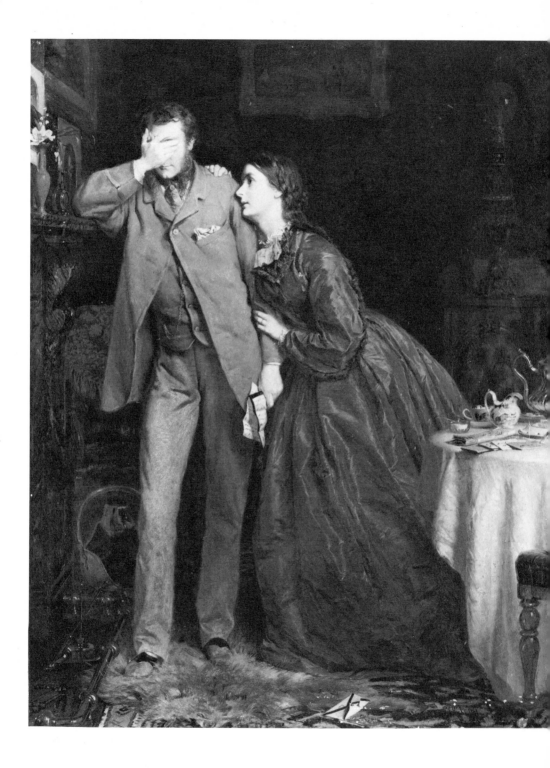

Every Picture

TELLS A STORY

Images of Victorian Life
with Commentary by
John Hadfield

Facts On File Publications
New York, New York ● Oxford, England

Every Picture Tells a Story
Images of Victorian Life
Copyright © 1985 John Hadfield

First published in the United States of America
by Facts on File Publications
460 Park Avenue South, New York, NY 10016

All rights reserved. No part of this book may be reproduced
or utilized in any form or by any means, electronic or
mechanical, including photocopying, recording or by any
information storage and retrieval systems, without permission
in writing from the Publisher.

Library of Congress Cataloging in Publication Data
Hadfield, John, 1907–
 Every picture tells a story.

 Includes index.
 1. Narrative painting, Victorian ——Great Britain.
 2. Narrative painting, British. I. Title.
 ND1452.G73H33 1985 759.2 85–7008
 ISBN 0–8160–1246–6

First published in Great Britain 1985 by
The Herbert Press Limited, 46 Northchurch Road, London N1 4EJ

Printed and bound in Great Britain

10 9 8 7 6 5 4 3 2 1

Contents

The border of the title page reproduces a specimen page for *Biblia Innocentium* designed by William Morris at the Kelmscott Press, 1892

The frontispiece reproduces a painting by George Elgar Hicks, entitled 'Woman's Mission: Companion of Manhood', 1863, *Tate Gallery, London*.

Acknowledgements

FIRST BECAME INTERESTED in 'story pictures' when, as a boy, I was taken by my mother during school holidays for a regular tour of the City Art Gallery in Birmingham. Being a sentimental and slightly morbid youth, I was deeply moved by Millais's 'Blind Girl', Arthur Hughes's 'The Long Engagement', and 'The Last of England' by Ford Madox Brown. And I fell in love with the girl in Millais's 'Waiting'. I now gratefully acknowledge the contribution my mother and the Birmingham Corporation made to my education in art.

Later my instinctive interest in story pictures was rationalized by Sir Sacheverell Sitwell's book on *Narrative Paintings* (1936). Later still I found that James Laver shared my interest; and as Editor of *The Saturday Book* I persuaded him in 1956 to contribute a witty commentary on the subject. It may have been this which inspired Mr Raymond Lister to produce his monograph on *Victorian Narrative Paintings* in 1966, which inevitably covers some of the same ground as mine.

As Editor of *The Saturday Book* I was constantly calling for expert guidance on Jeremy Maas, the gallery owner whose *Victorian Painters* (1969) is a standard work. I am also deeply indebted to Mr Graham Reynolds's *Victorian Painting* (1966). Another book which I have found useful as a quarry for little-known paintings is *Victorian Panorama* (1976) by Christopher Wood. Mr Wood's massive *Dictionary of Victorian Painters* (2nd edition, 1978) has also been invaluable; and I have derived much help from the very scholarly notes by Rosemary Treble to the Catalogue of the Arts Council Exhibition of Great Victorian Pictures in 1978.

Shortly before his death I was privileged to be shown round his collection of Victorian paintings by Evelyn Waugh, one of the few collectors who had the perspicacity to buy them when they were quite out of fashion. Another collector was Sir David Scott, a man who has an unerring eye for the story element in a picture, and who has generously contributed more to my researches than anyone else.

I thank a number of private collectors whose contributions to this book have mostly to be anonymous, for reasons of modesty and/or security. Of the eighty paintings reproduced in this book no less than twenty-four are in private ownership, and several of these have never been exhibited or illustrated hitherto. I am also grateful to the art dealers and public galleries which have given permission for their paintings to be reproduced. I would particularly like to mention the help I have had from galleries outside London, such as the Usher Gallery at Lincoln, the Wolverhampton Art Gallery, the Bristol Art Gallery, and the Ashton Bequest in the Tunbridge Wells Museum. J.H.

Introduction

ARRATIVE PAINTING, which is the academic term for pictures that tell a story, originated in what became known as the *genre* paintings by Dutch and Flemish artists in the seventeenth century. Painters such as Pieter Brueghel, Ostade, Jan Steen, Pieter de Hooch and Terborch turned aside from the portraiture, landscapes and seascapes practised by their great contemporaries like Rembrandt, Rubens and Ruysdael and preferred to paint small 'cabinet' pictures of contemporary domestic scenes and low life.

The movement was mirrored in France by Greuse and Chardin during the eighteenth century, and in England by Hogarth, whose 'Harlot's Progress' (1731), 'Rake's Progress' (1735) and 'Marriage à la Mode' (1745), popularized throughout Britain as engravings, were the precursors of English story painting.

The great British painters of the Romantic period, however, did not follow in Hogarth's footsteps. Gainsborough, Reynolds, and Raeburn were chiefly occupied with portraiture, whilst Constable and Turner concentrated on landscape. Other, lesser painters turned to historical subjects or scenes from literature.

Among these was William Powell Frith, who might have gone down in art history as a negligible and unoriginal painter of 'costume' subjects if he had not taken a holiday at Ramsgate in 1851. 'Weary of costume painting,' he wrote in his *Autobiography*, 'I determined to try my hand on modern life, with all its drawbacks of unpicturesque dress. The variety of character on Ramsgate Sands – all sorts of conditions of men and women were there. Pretty groups of ladies were to be found, reading, idling, working, and unconsciously forming themselves into very paintable compositions.'

The consequence of this realization was 'Life at the Seaside' or 'Ramsgate Sands', a canvas over sixty inches wide, which depicted in precise detail over a hundred men, women and children. It was bought by Queen Victoria at the private view of the Royal Academy for a thousand guineas. This was followed in 1858 by Frith's most famous panorama, 'Derby Day', which is even more thickly populated, and in 1862 by 'The Railway Station', which includes a variety of vignettes of social situations – anxious, amusing or dramatic. Frith followed these paintings with several moralizing series, in the Hogarth vein, such as 'The Road to Ruin' (1878) and 'The Race for Wealth' (1880).

Meanwhile a number of lesser painters had turned their backs on the great romantics and were going back to the Dutch tradition of small cabinet paintings. It is from these painters, who provided a large part of the output of Victorian

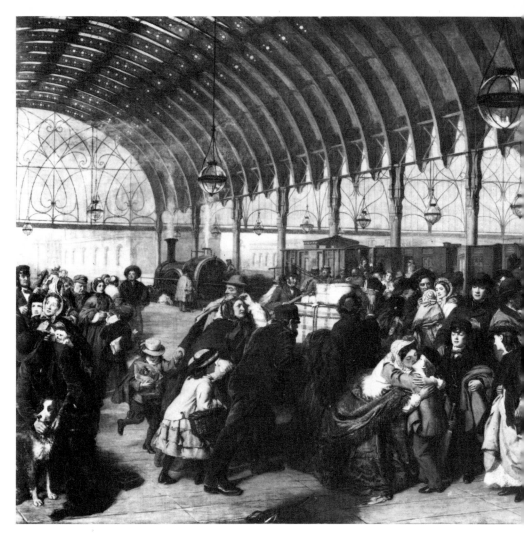

THE RAILWAY STATION, 1862

paintings throughout the reign of Queen Victoria, that most of the illustrations in my book have been drawn.

Owing to the width of their canvases and the profusion of characters depicted, Frith's panoramas do not lend themselves to reproduction in a book of relatively small size, and the same applies to some other splendid Victorian panoramas, such as Abraham Solomon's view of Brighton Front and George Elgar Hicks's

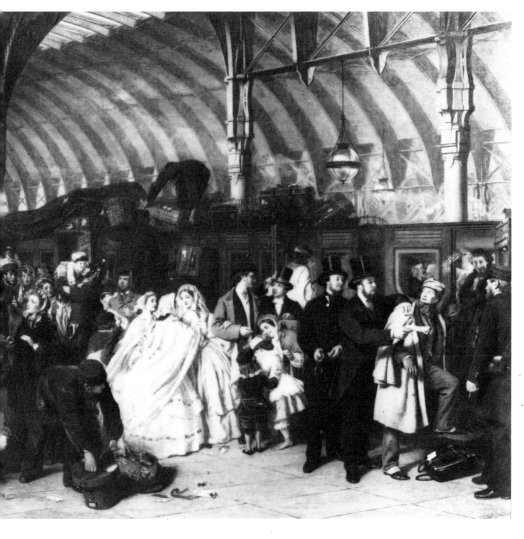

William Powell Frith, RA

views of Billingsgate, the General Post Office and the Bank of England. Even allowing for the exclusion of these giants (in every sense) there is a vast field of unexplored wealth amongst the painters of less ambitious story paintings.

My illustrations, therefore, are chosen mostly from the small cabinet paintings by followers of the Dutch tradition, such as Thomas Faed and Thomas Webster, and an interesting group of talented and socially 'concerned' artists who gathered

INTRODUCTION

round Webster, F. D. Hardy, G. B. O'Neill and, later J. C. Horsley, at Cranbrook in Kent. They did not deliberately seek to live 'the simple life'. Indeed, several of them also had houses in London, and enjoyed considerable financial success with their exhibits at the Royal Academy. But their interest was in domestic scenes of farmhouse and cottage life, and the normal, recognizable human problems that are common to the ordinary man and woman.

These painters reached a remarkably high standard of artistic accomplishment, largely because of the teaching offered by the Royal Academy and other schools, and the opportunities of exhibition offered not only by the Royal Academy but by the Society of British Artists, which came into being in 1824, and was given a Royal Charter in Queen Victoria's Jubilee Year. As craftsmen in their chosen profession, a number of quite obscure Victorian painters were just as accomplished as the earlier Old Masters.

Another factor that influenced their skills and their relative prosperity was the growth, throughout the Victorian period, of an educated and well-to-do middle class – professional men and successful manufacturers – who were willing to spend money on paintings for their newly built and newly furnished homes. This new class of patron, as distinct from the aristrocratic patrons and the squirearchy of the eighteenth century, flocked to the Royal Academy and the RBA and exhibitions of comparable organizations in provincial centres such as Liverpool, Manchester, Bristol and Birmingham. They were interested in art. But of them it was undoubtedly true, in the words of the old cliché, that they 'knew what they liked'.

They shared the familiar interests of their families and friends. There was a ready market for sympathetic or humorous paintings of children, in their normal activities and games, at birthday parties or Christmas gatherings, or 'pretending' to be engaged in such new-fangled activities as photography. It was – a cliché again – the age of the child.

The family was the central feature of middle-class social life; and paintings of family groups, ranging from humble gatherings to hear readings from the Bible to the glitter of the ballroom so dazzlingly portrayed by Tissot, were just what buyers asked for to decorate the walls of their drawing rooms. Having myself been brought up in just such a family household, in a Betjemanesque mansion built by my tradesman great-grandfather in 1873, my chief recollection of childhood is of a large dining room in which every wall not occupied by a sideboard or an aspidistra was hung from floor to ceiling with oil-paintings in massive gilt frames.

INTRODUCTION

There was an obverse side, however, to the coin of cosy middle-class family life, with mother and children turning the pages of an illustrated *Keepsake*, or listening to an aunt at the piano warbling 'We met, 'twas in a crowd' or 'The Mistletoe Bough'. On the other side of the coin, if one dared to look at it, were frightening images of adultery, gambling debts, social disgrace, bankruptcy, fallen women, emigration, or – worst of all – the workhouse.

With no National Health Service or Unemployment Relief to cushion the unfortunate, and stern social disgrace for those who transgressed the social rules, there was a constant undercurrent of 'fearing the worst'. Men who transgressed the rules of sexual morality might be tolerated and forgiven – or 'not found out'; and there were 'dens of iniquity' readily available to them where their aberrations could be indulged. A much greater hazard for them was the fear of losing money, more often than not through gambling.

Women who transgressed any of the rules were ruthlessly unforgiven, though there were occasional exceptions. It has only recently become known that a Miss Shell, who was governess to the four children of the Member of Parliament who founded *The Lady*, 'The Journal for Gentlewomen', and was later appointed Editor of that extremely respectable magazine, bore at least three illegitimate children to the proprietor.

Artists traditionally lead irregular lives, and there were quite a few, including some of the most respectable, like Frith or Holman Hunt, who shamelessly lived with mistresses. They didn't hesitate to depict the obverse side of the coin to viewers, who would draw their skirts around them, or light a cigar, and murmur 'There but for the grace of God goes . . .' This element in the popular art of the period is what has given the Victorians a reputation for hypocrisy. It is, I think, fairly represented in this book, though I am the last to sneer at the sentimentality of the other side of the coin, which represents the golden age in which many of our great-grandparents happily lived and brought up their children.

Both sides of the coin are represented in the story paintings of the period. Curiously, the group which was most deeply influenced by purely aesthetic considerations, the Pre-Raphaelites, often interpolated a strong story element in their paintings, with moral or emotional implications, and a fascination with enigmatic or puzzling titles for their pictures. The best Pre-Raphaelite paintings are now so well known, however, that I have represented in this book only those that I regard as key contributions to the Victorian ethos.

Favourite themes of other story painters were scenes of traditional village activities and traditional village characters. The Old England, based on a rural

[11]

economy and rural craftsmanship, was a welcome contrast to the rapidly developing industrial *milieu* from which much of the wealth of the growing middle classes was derived. The new connoisseurs might live in the suburbs of manufacturing towns, and make their money out of nuts and bolts and bricks and boilers, but they retained a sentimental attachment to woodland and pasture, horse and cart, and the social round of village life. Village weddings, going to church, dame schools, meets of the hunt outside the village inn – these were the favourite images for the adornment of suburban parlours.

Indeed, these still remain today amongst the favourite images for folk-art products such as Christmas cards and the covers of chocolate boxes. 'The Good Old Days' is an undying theme, and in the Victorian and Edwardian eras it brought a steady income to celebrants like Birket Foster, Marcus Stone and Heywood Hardy.

Fox hunting had been the staple theme of sporting art through the eighteenth century, and continued to have its devotees and skilled practitioners through the first half of the nineteenth century, but as the dukes and squires were forced to accept the company of Mr Jorrocks and his friends, so the classical equestrian artists like Stubbs and Sawrey Gilpin and Ferneley gave way to homely sentimentalists like the Herring family and other painters of farmyard and field, amongst whom the doubted master was Landseer.

Dogs – or, to be more exact, hounds – had always had their minor place in sporting art, and were the subject of some of Stubbs's finest animal portraits. But the dog as pet and companion to man and woman became a constant component of the mid-Victorian domestic scene.

The other constant element in the ever-expanding bourgeois environment was the family servant. The great houses had always employed many servants, but the rise of the middle class in Victoria's reign meant that countless modest family homes were now able to support their parlourmaids, their housemaids, even their housekeeper, butler and 'boots'. These mostly came from rural backgrounds and absorbed vast numbers of young women whose prospects of marriage in a restricted rural community were obviously limited. There was also a large in-between class of domestic employee, socially above the manual workers, who probably came from the village shop-keeping class or the lower professional levels, and who possessed skills or learning above the level of the usual domestic servant. These became seamstresses or governesses – both favourite subjects for painters. But they were not allowed to transcend their social origins, and they had to reconcile themselves, unless they possessed special intellectual qualities, to being regarded

INTRODUCTION

as part of the Lower Orders – a phrase that was used in all seriousness, and without any conscious social stigma, until the first Great War.

A quite separate social group, which attracted a surprising amount of artistic attention throughout an era which was on the whole remarkably free from war, was the Army. There were not, of course, nearly as many soldiers depicted in plays and novels during the post-Waterloo period as there had been during the almost continuous sequence of wars during the eighteenth century. But still the glamour of uniform remained, and a commission was still the usual fate – or privilege – of younger sons. Fortunately for painters, the Crimean War and the Indian Mutiny, though little more than 'local engagements', provided the artists with plenty of copy.

I should mention finally some of the inevitable limitations of my selection. Owing to the profusion of talented painters in the nineteenth century I have had to exclude those who specialized in historical or literary scenes, religious subjects, or classical studies (which became enormously popular towards the end of the century, and provided rich patrons with respectable visions of naked ladies posing in the interest of Art).

My special interest in story paintings lies in the light they throw on what Frith and his followers always referred to as 'modern life' – the contemporary scene, its ideals, fears, social usages and behaviour.

Not for a moment do I suggest that the eighty or so paintings reproduced here are the *best* examples of Victorian art. Some of the finest examples of the work of great artists have been omitted because they do not exemplify the theme of the book. I have omitted others because they are over-familiar. This has enabled me to include a number of paintings that are perhaps unfamiliar to many readers, including over twenty that are in private ownership and have been seldom illustrated or exhibited. To give perspective to the selection, nevertheless, I have included a few paintings, like 'Bubbles', Tissot's 'The Last Evening' and Ford Madox Ford's 'The Last of England' which are among the world's favourites.

Obviously the story element in most of the paintings is there for everyone to read, and in such cases my comments refer more to the circumstances in which the picture was painted, or its implications as an indication of the Victorian way of life. In a large number of instances, however, the story is not entirely easy to 'read', and the painting is open to various interpretations. In some of these cases my interpretations may be disputable, and I hope no ghosts of the artists will be looking over my shoulder.

INTRODUCTION

Also, mid-twentieth-century viewers must recognize that many Victorian attitudes were indeed *very* sentimental, even to the extent of appearing slightly comic to modern eyes. I hope I have recognized the amusing element in some of the situations depicted, without becoming patronizing or snide. The amusingness of many of these story paintings is a large part of their charm, just as rococo affectations were a large part of the charm of eighteenth-century art.

Whilst retaining the right to laugh at some of the situations depicted, and particularly at the titles chosen for them by the painters, I stand firm in my admiration of the painterly skill and aesthetic competence demonstrated by almost all the artists here represented. Naif art has its virtues and interest, but there is very little that is naif in this book. Sentimental and moralistic many of the painters may have been, but at least they had all learned how to draw, paint and compose. The fashion-followers of the nineteen-twenties and thirties who allowed such paintings to be virtually given away at auction to a few eccentric collectors, such as Sir David Scott or Evelyn Waugh or the Sitwells or Tom Laughton, are now being put to shame by the prices which even modest Victorian story paintings are fetching at auction today. It is not too much to say that Victorian story paintings, even by minor artists, are becoming one of the most promising quarries for collectors today.

The paintings reproduced on pages 24–25, 32, 33, 37, 48, 77, 80, 104–105, 108, 112, 117 and 128 were specially photographed in colour for this book by Derrick Witty.

[14]

Angel-Infancy

Happy those early days, when I
Shin'd in my angel-infancy.

HOSE LINES WERE WRITTEN by Henry Vaughan in the seventeenth century, a period whose ethos and social outlook were totally different from those of Victorian England. Yet, surprisingly, they express the general attitude of Victorian artists to children. Victorian England was in many ways corrupt and hypocritical, but it had a profound feeling for the innocence of childhood. The children of the very poor were, of course, condemned to certain forms of slavery; but so were their parents. The better-off and more intelligent sections of the community respected the innocence of children, and indeed, if not always understanding them, were proud of them, amused by their childishness, and deeply protective of their innocence. There may be something in the present-day view of the severe Victorian paterfamilias, who spoilt the child if he spared the rod; and no doubt many children were the victims of Dotheboys Hall or Dickens's blacking factory, but the image of the family as depicted by the majority of Victorian painters is a singularly happy one, and it is rare to find the features of a child, especially a girl, painted other than with affection. This is especially apparent in the attitude of the more serious artistic groups such as the Cranbrook School. Their view of children was formed more by the writings of Blake, Lamb and Wordsworth than by the hearty outlook of the Regency bucks.

From a historical point of view these paintings of childish activities are informative and revealing, as showing the occupations and recreations of children at a time when few mechanical aids to entertainment were available, apart from the early camera and the bicycle, assisted occasionally by visits from itinerant performers of peepshows and Punch and Judy puppets. These paintings too are interesting in showing the dominance of family life – the large family groups gathered to listen to bible readings, or celebrations of birthdays or going to church.

Inevitably sickness and death in childhood were ever-recurring themes in family life, and it is not surprising that engravings of 'The Doctor' by Sir Luke Fildes brought him a vast income. A less constant hazard was child-stealing, usually attributed to gypsies; and the painting by Charles Hunt which is reproduced here (for the first time) is a dramatic example of the threat to law-abiding family life which this menace presented.

[15]

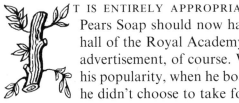

T IS ENTIRELY APPROPRIATE that this famous advertisement for Pears Soap should now hang, on permanent loan, in the entrance hall of the Royal Academy in Piccadilly. It did not start life as an advertisement, of course. When Millais painted it, at the height of his popularity, when he boasted that he could earn £40,000 a year if he didn't choose to take four months' holiday, the original title of the painting was 'A Child's World'. It was intended to symbolize the charm and wonder of childhood. Both the painting technique and the child's costume are reminiscent of child portraits by Reynolds.

Curiously enough, after it was first exhibited in Tooth's Galleries in the Spring of 1886, where it was bought by William Ingram as a colour plate for the *Illustrated London News*, it was not as immediately popular as Millais's 'Cherry Ripe' had been. The *Magazine of Art* dismissed it as being 'more vulgarly robust and sloppily effective than usual'.

However, T. J. Barrett, the Chairman of Pears, who was an ardent believer in advertising, saw the painting's possibilities. His firm had been publicizing a baby boy washing his feet with Pears soap, and Barrett saw that Millais's creation could be equally effective, as well as having the *cachet* of being 'art'. He bought the painting from the *Illustrated London News* for £2,200, and obtained the artist's permission to add a bar of soap to the painting when it appeared as an advertisement. Despite some evidence to the contrary, Millais seems to have had little objection to the painting being used commercially. It was in this context that in the course of time it became one of the world's most famous paintings, and a permanent symbol of the Victorian ideal of childhood as well as an injunction to cleanliness.

A curious element in its history is that Beatrix Potter's father, who was a capable amateur photographer and a friend of Millais, posed and photographed the model, Millais's grandson, Willie James, in order to assist the artist. The model grew up to be the distinguished Admiral of the Second World War, Sir William James.

A. & F. Pears Ltd.

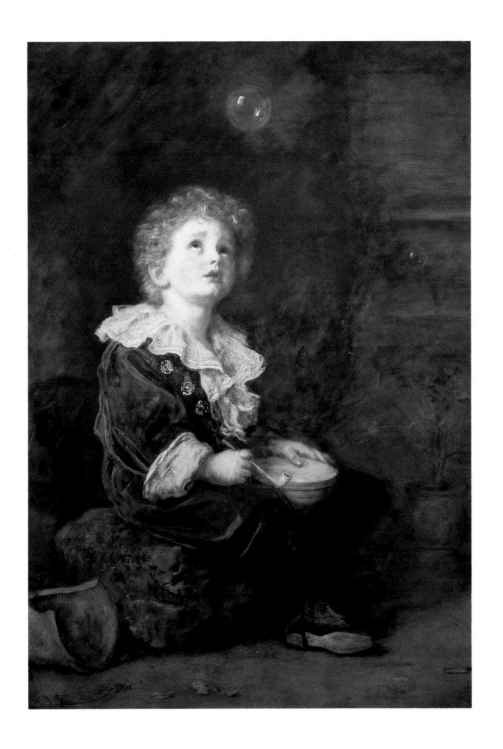

T IS RIGHT that this section of the book should open on a character-istically Victorian note of family affection, and that the painter should have been a man deeply in love with a beautiful young wife and mother. Arthur Boyd Houghton was an artist of versatile talents, who became an outstanding magazine illustrator and painted several delightful crowd scenes of London and seaside life. Perhaps he was *too* versatile. For three brief years, however, his thoughts, emotions and artistic talents were concentrated in his passionate love for Susan Elizabeth Gronow, some five years younger than himself, whom he married in 1861.

Susan's beauty is celebrated in a number of paintings and book illustrations, in which she was accompanied by her first two children, Arthur and Georgina. She died in 1864, from blood poisoning, after giving birth to her third child. All Houghton's paintings and engravings of her and her children are, to quote Houghton's biographer, the present-day painter and illustrator, Paul Hogarth, 'superbly drawn evocations of the warmth and intimacy of his family life, heightened by the fragile, almost doll-like beauty of Susan.'

The painting reproduced on the opposite page derives from an illustration drawn by Houghton for a poem 'My Treasure', signed by the initials 'R.M.', and engraved by the Dalziel Brothers for the magazine *Good Words* in 1862. In the painting, as in the engraving, the boy is playing 'Coach and Horses' with his mother's hair, watched by his infant sister. Although the study for the engraving is drawn from the other side of the room, the chair in which Susan is seated in the painting is the same as in the engraving, but she wears a different dress. The view through the window would presumably be of the garden of the Georgian cottage, at 4 Adelaide Villas, St Mary's Grove, Richmond, where the Houghtons lived.

There is a small full-face portrait of Susan by Houghton in the Tate Gallery, and she and her children also appear in Houghton's well-known painting of 'Ramsgate Sands' in the Tate, and in 'The Donkey Ride' in the Fogg Art Museum, Cambridge, Mass. The children are seen with a dog, in a small oil-painting in the Ashmolean Museum, Oxford.

The death of Susan, after only three years of marriage, shattered Houghton. He tried to divert himself by travelling in America and France, but, as E. J. Sullivan wrote, by 1872 he had embraced 'a feverish life of such excitement as the Bohemia of the day provided', and at the age of thirty-nine he died, leaving his enchanting wife and children mirrored in several beautiful works of art.

Sir Geoffrey Agnew

[18]

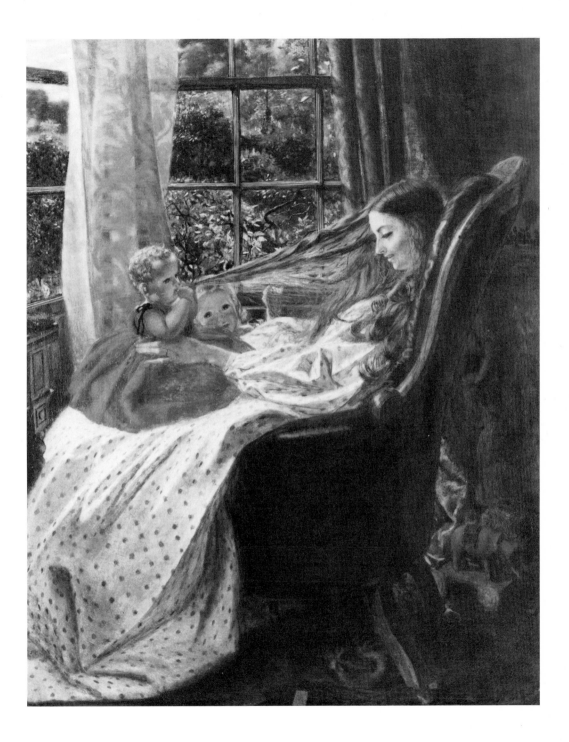

BABY'S BIRTHDAY, 1867 — *Frederick Daniel Hardy*

T IS DIFFICULT TO establish any priority amongst the painters who gathered together to form the Cranbrook Colony in Kent. Webster became the father figure of the group, but Frederick Daniel Hardy had in fact arrived in Cranbrook earlier than Webster, However that may be, they seem to have shared a studio, and there is a close correspondence between their choice of subjects and treatment of them. Webster was essentially a painter of environments and a certain humble way of life. Although Hardy had Webster's interest in, and understanding of, children and their games and recreations, his paintings tended to have a more anecdotal element. Something particular is always happening.

Baby's birthday is clearly being celebrated as something of an occasion – even for the cat – and the moment chosen to commemorate it is when the grandparents arrive. This painting was shown at the Royal Academy in 1867.

Wolverhampton Art Gallery

[20]

GOODNIGHT, 1846 *Thomas Webster, RA*

ERE IS A DOMESTIC SCENE taken from a lower social level than that of Arthur Boyd Houghton and his beautiful wife. This is a typical family group in a typical farm worker's home. The painting unfolds like a frieze from left to right, following the last rays of the sun which pass across the room from the window, unifying the whole group. Grandfather sits at the head of the supper table alongside his eldest grandson, waiting whilst three younger children say goodnight to their father and a fifth says his prayers at his grandmother's knee. Beside her is the baby's cradle, and in the foreground corner the washbasin which has just been used. Up the steps on the right can be seen a bed in the room beyond.

Exhibited at the Royal Academy in 1846, this is an extremely skilful exercise in interior painting. The light is used to emphasize the chief descriptive parts of the painting, such as the faces of the family, whilst more incidental elements, such as the objects on the chimney piece or the wooden cot, are kept in relative shadow.

Sociologists might say that the subject is treated sentimentally and unrealistically, since this would obviously be a family living in a very modest environment. But Webster knew people like this, who surrounded him in his home at Cranbrook, and if he saw them as a happy family I guess that in fact they *were* happy.

Bristol Art Gallery

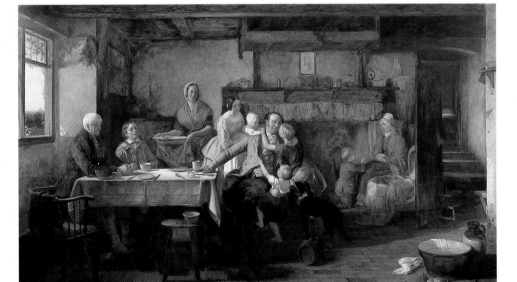

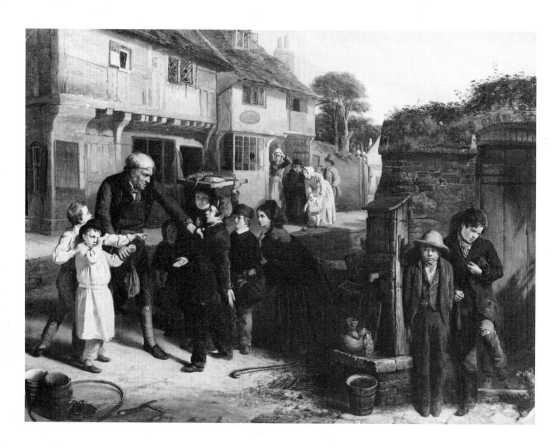

THE BROKEN WINDOW, 1855

William Henry Knight

 ESPITE HAVING EXHIBITED several paintings at the Royal Academy between 1846 and 1862, William Henry Knight is now a much underrated artist. This painting, which was exhibited at the Royal Academy in 1855, shows, as does the painting reproduced on page 28, his skill in organizing a number of figures, not in panoramic form, as Frith did, but in an 'action picture'.

How reassuring it is – and how delightful for viewers in succeeding generations – that in the middle of the Crimean War, when harrowing defeats and casualties were being reported every week in the press, a painter could look out of the window into his village street and quietly record in such detail, and with such fidelity, a tiny and quite insignificant event in English village life.

Wolverhampton Art Gallery

[22]

(*Overleaf*) THE STOLEN CHILD, 1870 *Charles Hunt*

TEALING CHILDREN is supposed to be a special crime of the twentieth century. Kidnapping children is what gets most public attention nowadays, though there are also cases of good-looking children being abducted by men with peculiar sexual predilections, and occasional instances of babies being lifted from prams outside shops by tragic women who have the misfortune to be childless.

Child-stealing, however, was also a common hazard of parenthood in Victorian times, though not, usually, for the above-mentioned reasons. Kidnapping was very rare. Most children were taken either for their value as cheap labour, or else for initiation into picking pockets and other nefarious activities of gangs like Fagin's. In the case of good-looking young girls there was always the danger of their being destined for the child brothels that abounded in the 'red-light' districts.

For some reason, probably mere prejudice, and never properly verified, the responsibility for most child-stealing was laid at the door of the gypsies. There was the familiar nursery ditty:

> *My Mother said I never should*
> *Play with the gypsies in the wood.*

There is no evidence in the painting reproduced overleaf that the villainous if somewhat shamefaced pair of women were in fact gypsies, though they may have been. What obviously interested the artist most was the triangular relationship between the pretty but terrified little girl, obviously a child of well-to-do parents, who is being stripped of her fine clothes, and the truculent son of the household, ready to defend his family's dishonour, and the policeman, whose general demeanour is by no means formidable, though he has his helmet and his uniform to enforce the majesty of the law.

Before the arrest takes place viewers should spare a moment for the skilfully painted filth of the surroundings, the plaster peeling off the wall, the lack of fire in the grate, the untidy straw on the floor. The vegetables, the pretty patchwork counterpane, and the ebonized stickback chair are obviously stolen property. The wicked master of the house is out poaching; his clay pipes are on the mantelpiece. He will be in for an unpleasant surprise when he returns.

From an artistic point of view it is quite a triumph to cram so much effective detail, and a highly-charged dramatic situation, into a tiny painting which is here reproduced in the exact size of the original panel.

Private Collection

[23]

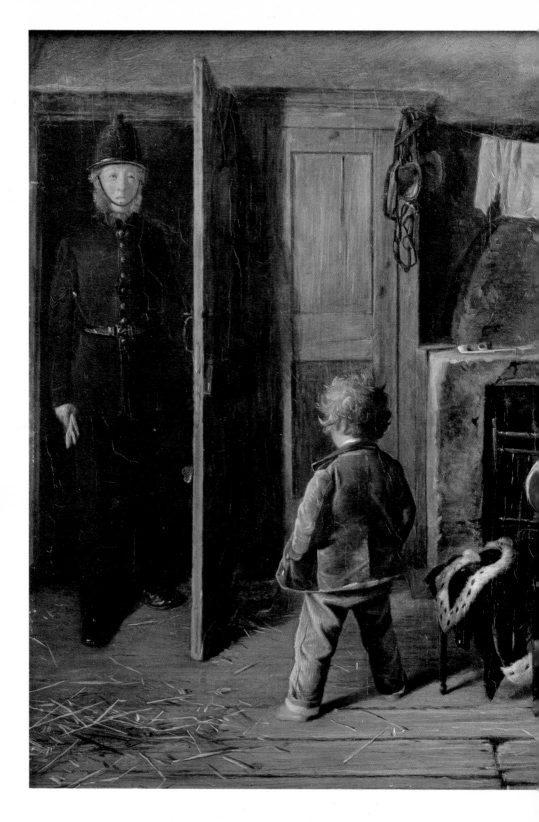

THE STOLEN CHILD: *See preceding page*

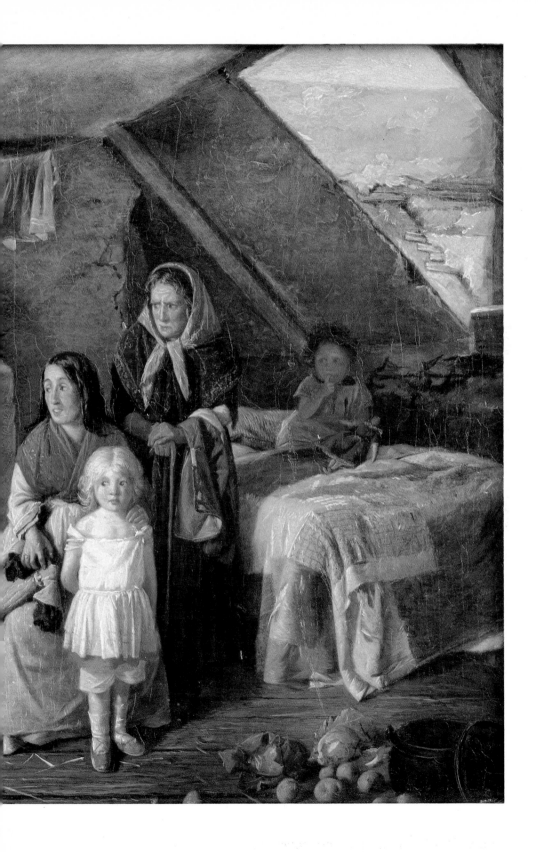

THE DOCTOR, 1891 *Sir Luke Fildes, RA*

VER A MILLION ENGRAVINGS of this enormously popular – and enormous (over five by eight feet in size) – painting were sold in Britain and the United States. The idea of the picture grew out of the artist's loss of his own first child on Christmas Day, 1877, watched over by the family doctor. The painting was commissioned in 1890 for £3,000 by Sir Henry Tate, who presented it to the Tate Gallery. In his determination to achieve the right atmosphere Fildes spent a week in Devon sketching fishermen's cottages; and he built a full-scale cottage interior in his studio in London. A number of doctors came to him in relays to pose for the central figure; but Fildes worked mostly from a professional model. The picture has survived the ignominy of being stored in the basement of the Tate Gallery for several years, as a result of scathing comments from Roger Fry and other 'advanced' critics of the 'twenties. Now, properly hung in one of the largest rooms, its self-confident bravura comes into its own.

Tate Gallery

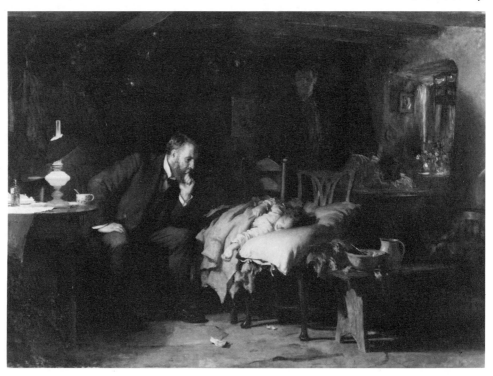

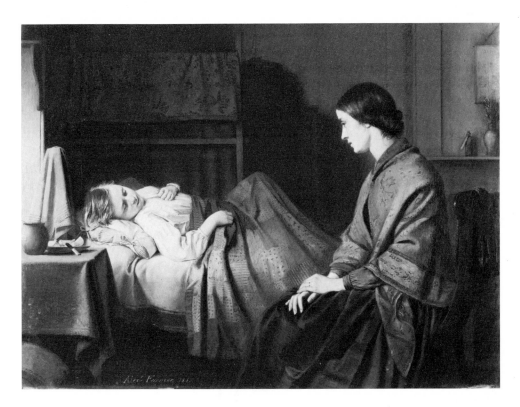

AN ANXIOUS HOUR, 1865 *Mrs Alexander Farmer*

RS FARMER WAS THE WIFE of a watercolourist, Alexander Farmer, living at Porchester in Hampshire. There is some doubt as to whether this picture was painted by her or her husband. It is signed 'Alex! Farmer 1865', but like other paintings exhibited in the Royal Academy between 1855 and 1867 the artist is indexed in the catalogue just as 'A. Farmer'.

Assuming that the artist was Mrs Farmer it is remarkable how accomplished her small volume of work is. There are clear parallels between the Farmer study, which is painted on a panel measuring only twelve by sixteen inches, and the vast scale of the Fildes painting. The mood of both is the same; but there is a sense of repose and restrained emotion in the Farmer painting, heightened by the clarity and exactness of the setting, which it is not altogether ridiculous to compare with some elements in paintings by Vermeer.

Victoria and Albert Museum

[27]

THE LOST CHANGE, 1859 *William Henry Knight*

HATEVER EXACTLY MAY BE THE CAUSE of the commotion in this painting, which was exhibited in the Royal Academy in 1859, it would be difficult to find one which brings together a more varied and representative collection of village people and distinguishes them all so skilfully. The elderly gentleman on his way home from church, accompanied by his wife and daughter, has either dropped or thrown down as a gift to the children some coins for which they are all eagerly hunting. It is perhaps a slightly contrived situation, but it enabled the artist to depict almost all ages of the village populace, and a really enchanting variety of jerseys, dresses, shirts, skirts and headgear. Moreover, the extraordinary variety of colours all blend most harmoniously and pick up the quieter colours in the village street. A comparison with a somewhat similar group on page 22 reveals the quite remarkable talent of this obscure painter.

By Courtesy of Richard Green

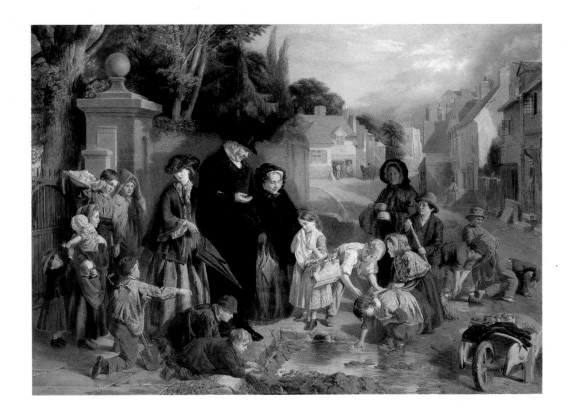

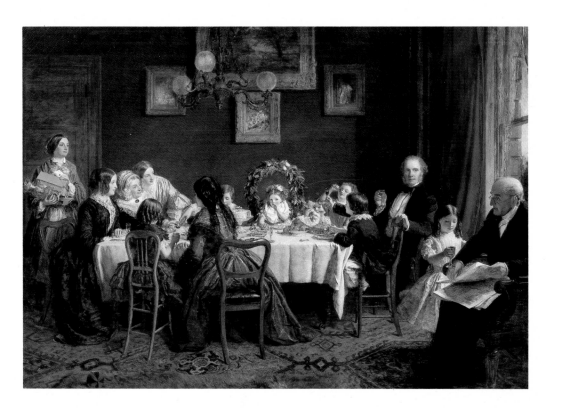

MANY HAPPY RETURNS OF THE DAY, 1854 *William Powell Frith, RA*

 HE BIRTHDAY CHILD was one of the artist's daughters, who later became Lady Hastings. Frith himself poses at the end of the dining-room table. His mother was the model for the elderly lady at the far end. The grandfather in the corner was perhaps deliberately separated from the family group since he has been brought in from the work-house, though Frith described him as 'an amusing old fellow, brim-ming over with wise saws and good advice'.

Ruskin praised this picture when it was shown at the Academy, commenting that it showed indications of Pre-Raphaelitism. This annoyed Frith, who regarded the painting as one of the worst he had ever painted. Whether or not as a sub-conscious response to Ruskin's comment, Frith followed the completion of 'Many Happy Returns' by painting one side of a sign for a public-house.

Harrogate Museum and Art Gallery

[29]

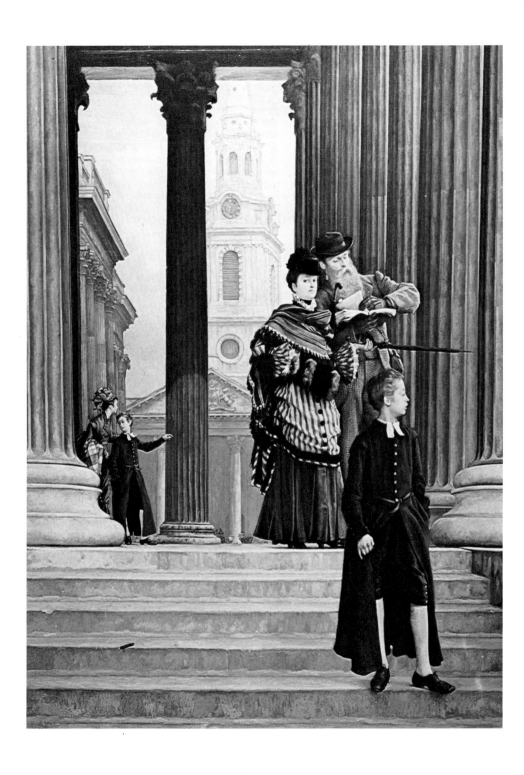

Opposite:
VISITORS TO
LONDON, 1884

James Tissot

*Museum of Art,
Toledo*

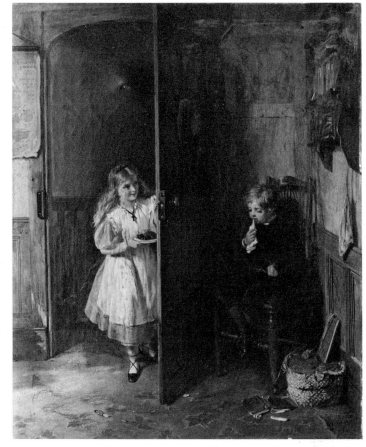

On the right:
THE NAUGHTY
BOY, 1867

G. B. O'Neill

*Wolverhampton
Art Gallery*

ERE ARE TWO strongly contrasted impressions of mid-Victorian boyhood. Above is a down-to-earth painting of a sulky 'provincial' youth whose misbehaviour has caused him to be exiled to the scullery of the farmhouse which is obviously his home, and which was the scene of many of O'Neill's homely low-life paintings. Opposite is Tissot's stylish view of rich tourists on the steps of London's National Gallery, being courteously escorted by scholars from the monastic splendours of Christ's Hospital. The scholars are dressed in their traditional uniform of white neck-bands, heavily-skirted dark blue gowns, and yellow stockings – an appropriate foil to the fashionably dressed lady who was always to be seen in Tissot's paintings. The only characteristic shared by the two pictures is that both were exhibited at the Royal Academy.

[31]

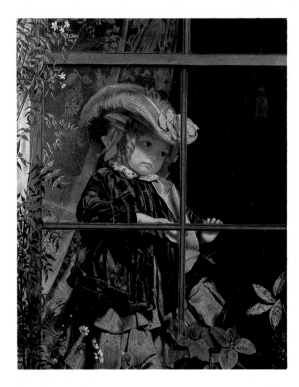

EARING IN MIND ITS TITLE, the subject matter of this charming sentimental painting calls for no interpretation. The raindrops on the window, together with the expression of disappointment in the child's eyes, tell the story. The surrounding flowers, almost Pre-Raphaelite in their detail, indicate that the time of year is midsummer, though the girl is dressed in winter clothes.

What is interesting, apart from the painterly skill of a relatively minor artist, is that this picture, although it has been in the same private ownership for over sixty years, has become enormously popular on both sides of the Atlantic. In 1856 it was listed for inclusion in *Photographic Art Treasures*, so it was evidently popular then. It was very beautifully reproduced in photogravure on the wrapper of Graham Reynolds's book on *Victorian Painting* in 1966. It was then pirated for greetings cards, and sold by Woolworths. It must now be one of the best-known Victorian paintings in private ownership. Yet its owner acquired it in the early nineteen-twenties at a sale room in Pall Mall, after it had failed to reach its modest auction reserve of £15. *Private Collection*

**THE JEWEL
CASKET**, 1866
*George Bernard
O'Neill*

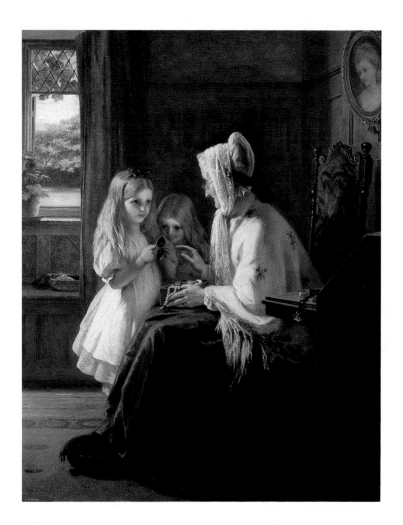

HERE SEEM TO BE SEVERAL versions of this painting, including a slightly smaller one in the City of London Guildhall Art Gallery called 'Gran's Treasures'. The version reproduced here was probably exhibited at the Royal Academy in 1866. It was painted at Cranbrook in Kent where O'Neill rented a timber-framed house, formerly a cloth hall. The two girls, who modelled for several of his paintings, were probably his daughters. The contrast of Age and Youth was a favourite subject for the artistic community which had settled at Cranbrook. The children almost always seemed to be blond, and their elders were usually equipped with a walking-stick or a footstool. *Private Collection*

[33]

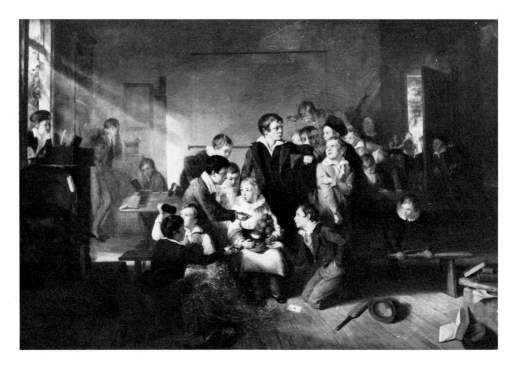

THE BOY WITH MANY FRIENDS, 1841 *Thomas Webster, RA*

 HOMAS WEBSTER, who was the son of a member of the Royal Household at Windsor and a member of the choir of St George's Chapel, might have been expected to become a fashionable portrait painter. The first painting he exhibited at the Royal Academy in 1823 was a portrait. Unexpectedly, however, he became interested in painting children, especially children in village schools. They are not entirely sentimental, and 'The Boy with Many Friends' could well be taken as an illustration of *David Copperfield*. But there is little malice in Webster's bullies, and it is easy to understand the appeal of their school-boy frolics in an age when 'the waggeries of mischievous schoolboys' vied with 'the humours of the dog-kennel' as *Fraser's Magazine* caustically described them, to become favourite subjects for parlour decoration. It needed *Tom Brown's Schooldays* to introduce a sterner note, but Webster was happy to go on painting the same idyllic scenes of boyhood throughout the century. The redeeming feature of his work is his mastery of figure drawing and child physiognomy.

The Art Gallery, Metropolitan Borough of Bury

[34]

THE MITHERLESS BAIRN, 1855 *Thomas Faed, RA*

ELEVEN YEARS AFTER it was first exhibited at the Academy in 1855 the *Art Journal* published an engraving of this picture with the comment: 'No description . . . could surpass the effects of the painter in the recital of the subject set forth in this admirable picture. . . . In it we see how far the painter's art may transcend that of the poet in the expression of a single idea.' When first exhibited the painting was accompanied by a quotation from *Rhymes and Recollections of a Hand-Loom Weaver* (1844) by the Scottish poet, William Thom. Faed was an accomplished painter, but perhaps his poetic touch occasionally strayed into poetic licence. The magazine *Good Words* claimed that: 'A little vagrant, on the plea that he had no father or mother, imposed upon the children of Burley Mill (Faed's home), who coaxed him to stay in the house, and fed and petted him until . . . he grew so insolent that he had to be turned away. It afterwards came out that he was not an orphan at all, but the son of two sturdy tramps who were the terror of the district.' *National Gallery of Victoria, Melbourne*

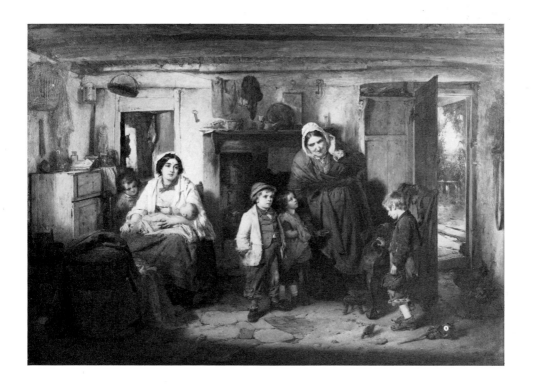

HER FIRST LETTER, 1857 *R. W. Chapman*

 ERE IS A CHARMING and accomplished painting by an artist whose dates of birth and death do not appear to have been known to the compilers of any of the reference books. All that is recorded is the exhibition of two historical paintings at the Royal Academy in 1855 and 1856, and a few watercolours submitted to the Society of British Artists between 1856 and 1861. Chapman appeared to live in Central London and at Wandsworth, but his first two names are not recorded.

Yet this is no novice's work. The relationship between the taut and upright figure of the girl, the vertical and horizontal bars of the windows, and the rounded shapes of the shopping basket and the lay-figure in the showcase, make an ingenious and visually rewarding composition. The soft tone of the whole painting emphasizes the thrill and earnestness of the girl's expression as her eyes follow her letter into the box. Just two or three touches of pigment brilliantly suggest the significance of the moment and the step which the girl has taken.

What message the letter carried nobody but the girl and the recipient will ever know, but this is a little moment of drama quietly but vividly captured in a setting of total ordinariness.

Incidently, this little painting is some further proof – beyond that given elsewhere in the book – of the importance of the written letter in an age before it was replaced by the telephone and telegram. This is yet another curious link between the 'cabinet' paintings of the Victorians and the *genre* paintings of the seventeenth-century Dutch and Flemish painters, who again and again used letter-writing as a significant element in their paintings.

One is tempted to query whether there is any symbolism in the lay figure in the showcase. Or is it just something the painter had readily to hand, and he placed it where it is in the interests of design?

Private Collection

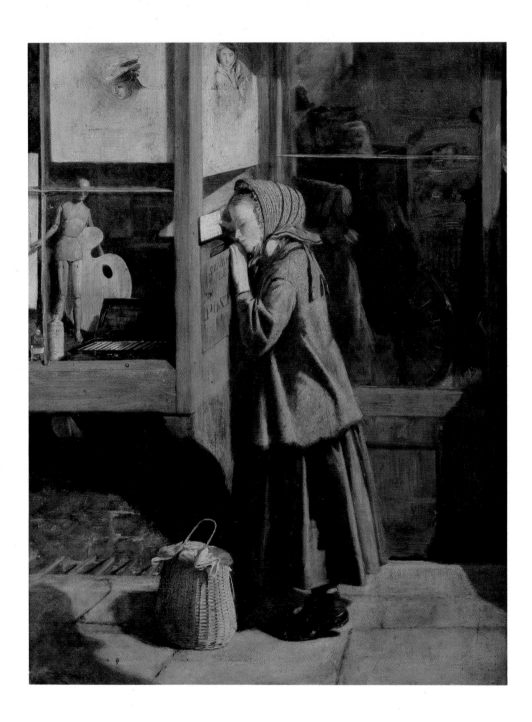

Love's Old Sweet Song

EARLY LOVERS, 1858 *Frederick Smallfield*

PRE-RAPHAELITE PAINTERS, both in their personal lives and in the themes of their paintings, tended to have a complex and uneasy attitude to love. Holman Hunt packed every sort of erotic symbol into 'The Awakening Conscience', and his own love life was a chequered one. The relationship between William Morris and his wife and Rossetti was distinctly triangular. In 'Too Late' William Lindsay Windus produced a masterpiece of erotic guilt. Even Arthur Hughes's exquisite 'April Love', so often taken as a simple hymn to first love, was in origin and conception a recognition of the fragility and impermanence of love.

To open this section of the book I have chosen a relatively little-known adherent of the Brotherhood, Frederick Smallfield, who seemed to have a much more straightforward attitude to love than the more sophisticated members of the group. Indeed the 'story' which this painting tells is a very simple one, which any viewer can read. It was inspired by Thomas Hood's ballad:

> *It was not in the Winter*
> *Our loving lot was cast;*
> *It was the Time of Roses,*
> *We pluck'd them as we pass'd!*
> *That churlish season never frown'd*
> *On early lovers yet:*
> *Oh, no – the world was newly crown'd*
> *With flowers when first we met!*

The Pre-Raphaelite element in the painting is represented by the tangle of ferns, leaves and roses. The treatment of the skyline recalls Millais, whom Smallfield knew as they were both members of the Junior Etching Club which in 1858 produced a series of illustrations to Hood's poems, etched by the different members.

Manchester City Art Gallery

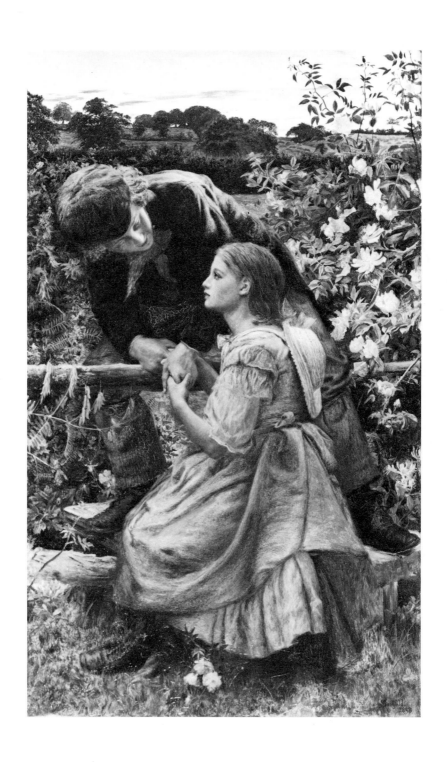

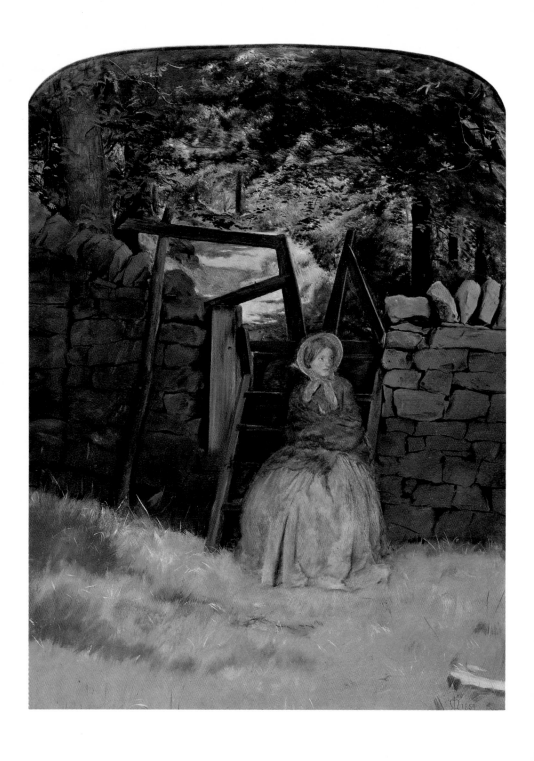

T IS ONLY FAIR TO FOLLOW the most famous example of advertising art with another subject-picture by the same artist which conveys no message other than pure emotion and that old-fashioned element – beauty.

Millais was a master of the story picture, as he demonstrated in such tear-jerkers – if that term can be used without disrespect – as 'The Order of Release', 'Mercy', 'The Eve of St Agnes', 'The Knight Errant', and 'The Huguenot'. He had a strong streak of the sensational journalist in his make-up. I have chosen 'Waiting' as a painting which unquestionably has a story-interest, but its emotional content is a genuine one, of simple and universal appeal; and as a work of art it has uncommon quality.

Its theme, of course, requires no explanation; and the symbolism of the stile, with the sunlit glade beyond, is fairly obvious. One can make up one's own mind as to the identity of the young man for whom the girl is waiting. What I particularly like about it is the simplicity of the composition – very beautifully painted – corresponding to the obvious simplicity of the emotion expressed in the girl's posture and expression.

I cannot pretend to have explored the biography of Millais or his correspondence with minute care, but I have found no evidence that he regarded this painting as being of any importance. It was not exhibited at the Royal Academy and there is no textual reference to it in Millais's *Life and Letters* by his son, though it is reproduced, without comment. I have not been able to discover who the model was. 'Waiting' was painted one year before Millais married Effie Gray.

City of Birmingham Museum and Art Gallery

OOLE IS TODAY A FORGOTTEN FIGURE. If he is remembered at all it is because of a scandal. Born in Bristol, the son of a grocer, he was self-taught as an artist, and became known chiefly because at the age of twenty he became involved with the wife of another – and much better-known – Bristol painter, Francis Danby. Eventually Danby eloped to Geneva with Poole's wife, taking with him a family of ten children, seven legitimate and three illegitimate.

Poole began to exhibit at the Royal Academy in 1830 and became an Academician in 1861. In 1843 he had been much praised for a theatrical painting of 'Solomon Eagle exhorting the People to Repentence during the Plague of London', and in 1847 he won a prize of £300 in a Houses of Parliament competition for 'Edward III's Generosity to the People of Calais'. He went on to paint much-acclaimed historical scenes, warmly praised by Ruskin and favourably discussed at some length in Graham Reynolds's *Victorian Painting*.

Graham Reynolds is enthusiastic about the technical merits and the highly personal colour sense shown in Poole's dramatic portrayal of 'The Last Scene in Lear', now in the Victoria and Albert Museum; and I would not dispute his judgement. Surprisingly, though, Mr Reynolds dismisses a number of Poole's 'routine pieces, smiling country girls with their children posed against the rocky streams of the West Country'. Admittedly Poole is said to have been 'a good hater and to have had much of the Savage in him', and there was striking evidence of this in his large historical or dramatic pieces. But he also had a lyric quality, and a gentle understanding of the young, which comes out delightfully in the small painting reproduced here. Despite certain weaknesses in drawing this seems to me to have a freshness and tenderness that is far from 'routine'. It puts me in mind of the lyric verse of the contemporary John Clare and Poole's fellow West Countryman, William Barnes. There were clearly two sides to Poole's temperament, and his self-taught talents were such as to make his whole work well worthy of re-discovery.

Wolverhampton Art Gallery

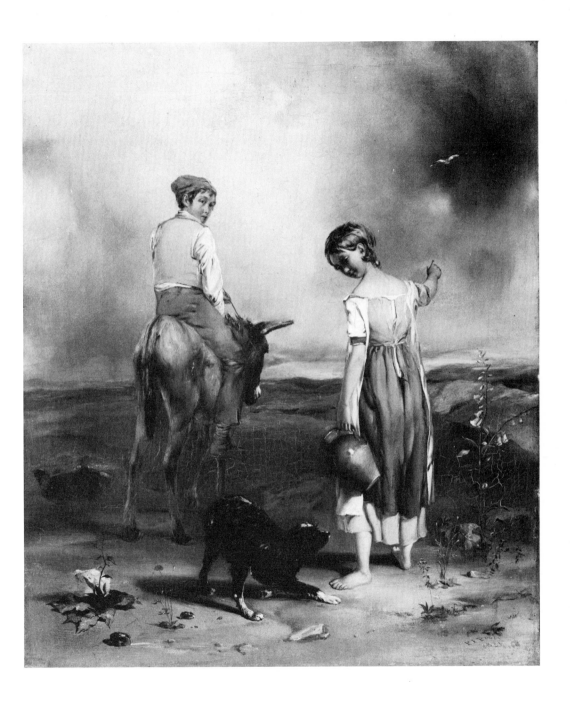

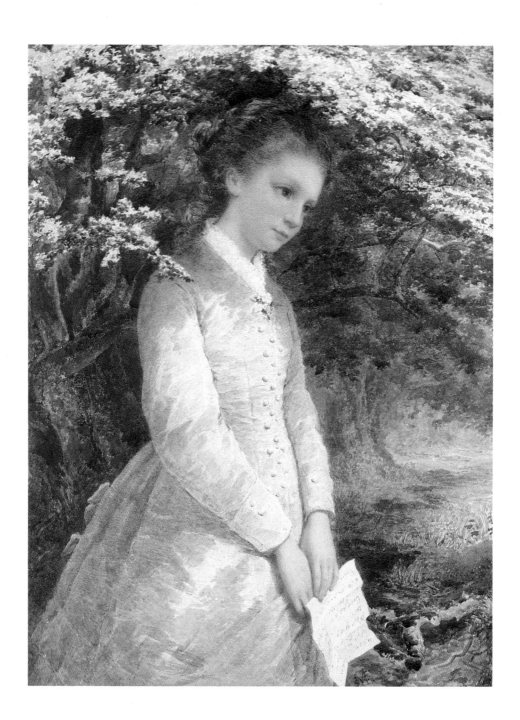

THE LOVE LETTER, *c.* 1840 *Margaret Sarah Carpenter*

 HIS IS THE ONLY WATERCOLOUR drawing included in this book. I have included it partly to emphasize how some very accomplished women artists were at work in the mid-Victorian period – see also pages 27 and 32 – and also because I know of no other painting which expresses so poignantly the reactions of a girl to what must have been a great moment in her emotional life. The depth of longing and reflection in her expression is most touchingly portrayed.

How one wishes one could read more than a few words of the letter, or could supply an appropriate text for it from some contemporary source! I have tried to find such a source, but all I have come upon is a passage from a letter written some twenty years earlier:

'My dearest Girl, This moment I have set myself to copy some verses out fair. I cannot proceed with any degree of content. I must write you a line or two and see if that will assist in dismissing you from my Mind for ever so short a time. Upon my Soul I can think of nothing else. . . . My love has made me selfish. I cannot exist without you. I am forgetful of everything but seeing you again – my Life seems to stop there – I see no further. You have absorb'd me. I have a sensation at the present moment as though I was dissolving – I should be exquisitely miserable without the hope of soon seeing you. I should be afraid to separate myself far from you. My sweet Fanny, will your heart never change? My love, will it? I have no limit now to my love. . . . 'Tis richer than an Argosy of Pearles . . . I have been astonished that Men could die Martyrs for religion – I have shudder'd at it. I shudder no more – I could be martyr'd for my Religion – Love is my religion – I could die for that. I could die for you. My Creed is Love and you are its only tenet. You have ravish'd me away by a Power I cannot resist; and yet I could resist till I saw you; and ever since I have seen you I have endeavoured often "to reason against the reasons of my Love". I can do that no more – the pain would be too great. My love is selfish. I cannot breathe without you. Yours for ever.'

That letter was written in 1819 to Fanny Brawne by John Keats. Are letters like that written today?

Private Collection: photograph by courtesy of Messrs Frost & Reed

[45]

ERE IS LOVE'S BITTER-SWEET SONG given the full Pre-Raphaelite treatment. Presumably Ford Madox Brown took his title from Hogarth's series of prints with the same title, on the theme of cruelty to animals. It is interesting to contrast the barbaric candour of Hogarth's engravings with the mild suggestiveness of Ford Madox Brown's conception. In fact, there is very little comparison at all! Whereas Hogarth's young ruffians are torturing every dog, horse or domestic hen within sight, and his quacks are performing unmentionable acts of surgery, Ford Madox Brown's young woman is merely giving a polite brush-off to her suitor, and her young sister is beating the patient blood-hound with a spray of Love-lies-bleeding. Thus standards of behaviour – and artists' comments on them – change in little more than a hundred years.

Ford Madox Brown was one of the most accomplished of the Pre-Raphaelites, and the careful treatment of the lilac leaves and the brick wall (in the artist's garden, as it happens) is a masterpiece of Pre-Raphaelite technique. But the theme of this painting, and the distinctly unsympathetic expressions on the faces of the two girls, suggest – as did others of his paintings, such as 'The Last of England' – that he had a morbid, almost a misanthropic, streak in his temperament. It is not surprising that this painting, begun in 1856, failed to find a buyer until it was re-commissioned and completed in 1890.

City of Manchester Art Gallery

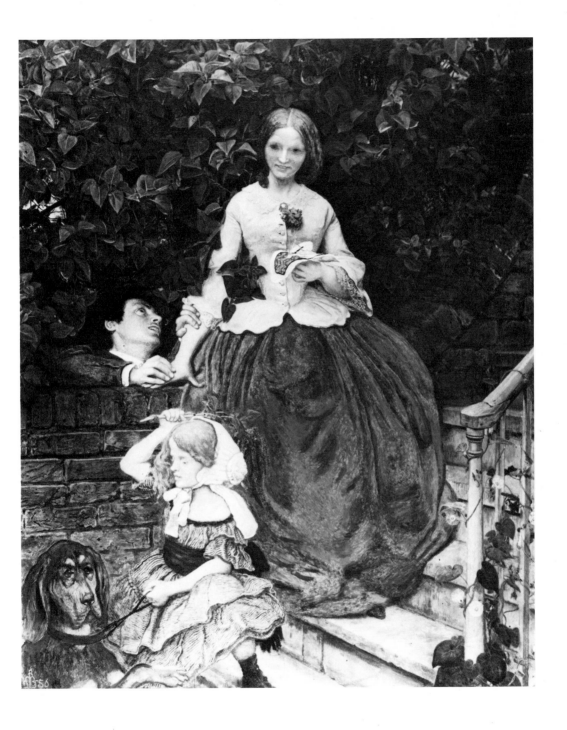

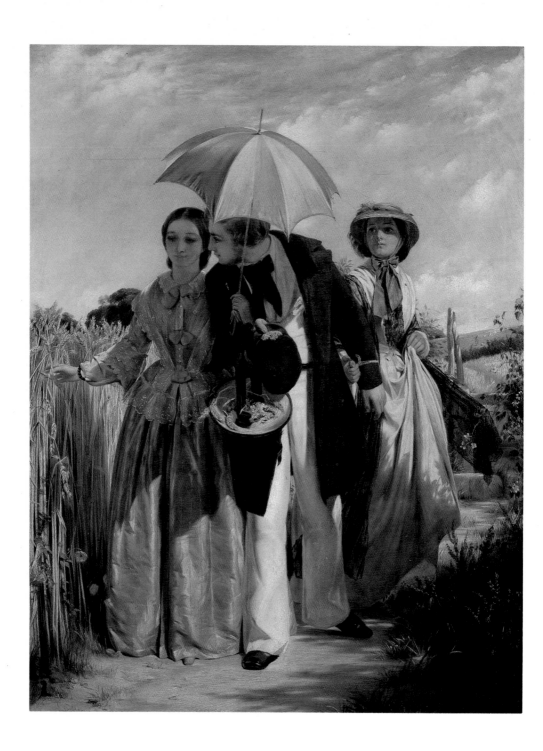

SHOWING A PREFERENCE, 1860 *John Callcott Horsley, RA*

 ORSLEY'S RECOLLECTIONS OF A ROYAL ACADEMICIAN reveal him as a rather serious and conventional person. When he became Rector of the Royal Academy his disapproval of the use of nude models earned for him the nickname of 'clothes-Horsley'. Yet when he abandoned historical subjects in the eighteeen-fifties and turned to paintings of contemporary life it appeared that his chief interest lay in what Graham Reynolds has described as 'scenes of flirtation set in the countryside'. Perhaps it is significant that in his autobiography Horsley proudly records that he was one of the first people to dance the polka when it was introduced into England. Perhaps he himself was a 'flirt', with a taste for gallantry. Paintings he showed at the Academy in the late 'fifties had such titles as 'Attraction', 'The Pet of the Common', 'A Jealous Eye' and 'Under the Mistletoe'.

When 'Showing a Preference' was exhibited at the Academy in 1860 *Punch* commented: 'Mr Horsley's naval lieutenant (HMS *Trifler*) is showing a preference in a very indiscreet and decided manner. The very poppies hang their heads in shame. Let us hope that he has made a fitting choice and that his charmer will become a mate before he is a Commander'. A typical *Punch*-line!

The present owner of this painting endorses *Punch*'s strictures but attributes the discarded girl's petulance partly to the fact that she is entangled in a bramble. A possible consolation for her, unless I am much mistaken, is that the same girl who modelled this part was painted three years later by the same artist in a picture entitled 'St Valentine's Morning' (see page 51).

The only comment on 'Showing a Preference' made by a farming friend was that 'wheat was very long in the straw that year'. The painting is, nonetheless, a delightful reminder of days when courting couples – or threesomes – could and did habitually go for walks along well-trodden footpaths through the fields. There is a lovely little painting by Richard Burchett in the Victoria and Albert Museum showing just such a path.

Private Collection

S SHE, OR IS SHE NOT, the same young woman who was being rejected in Horsley's painting, 'Showing a Preference', which is reproduced on page 48? She certainly bears a resemblance, and has the same haughty demeanour. But, alone in her boudoir on St Valentine's Morning, she can feel a lot more cheerful as she reads the missive that has just been brought in by the housekeeper. Who is the anonymous correspondent? she speculates. Surely it cannot be that ill-mannered young naval lieutenant who took her and her so-called friend for a walk through the fields! Anyway, that was three years ago. Perhaps he's a Commander by now!

It is an innocent little guessing game, but Valentines filled what undoubtedly was a long-felt need in the lives of Mid-Victorian spinsters (as, indeed, they probably would today if the whole concept had not become commercialized and vulgarized by the stationery trade and the advertising managers of the newspapers).

The vast popularity of Valentines dates from the introduction of the penny postage rate by Sir Rowland Hill on January 10, 1840. Before then, at fourpence per letter, anonymous declarations were an expensive method of making known one's passion.

Why, you may ask, were they called Valentines? They take, it seems, their name from Valentinus, a priest who was condemned by the Emperor Claudius to be stoned and beheaded. On the eve of his execution he wrote a note to the blind daughter of his jailor, signed 'From your Valentine'. The date was February 14, AD 270. In Samuel Pepys's day Valentines were somehow associated with a lottery, and Pepys recorded in his diary for St Valentine's Day in 1667: 'This morning came up to my wife's bedside (I being up, dressing myself) little Will Mercer to be her Valentine, and brought her name written on blue paper in gold letters, done by himself, very pretty; and we were both well pleased with it. But I am also my wife's Valentine, and it will cost me £5.'

Seventeenth-century Valentines, in more exalted circles, were rather more than sentimental. Mrs Frances Stuart, a mistress of Charles II, who afterwards became Duchess of Richmond, was so well favoured that on one Valentine's Day she received a jewel worth £800 from the Duke of York, and in another year a ring worth £300 from Lord Mandeville.

In the eighteenth and nineteenth centuries, however, Valentines became labours of love devised by young men as genuine declarations of love, inscribed with tender verses and decorated with flaming hearts, Cupid's bows and flowers with especial connotations of passion. Stationers were quick to evolve ingenious patterns with embossed paper or applied lace, tinsel, shells and feathers. They

[50]

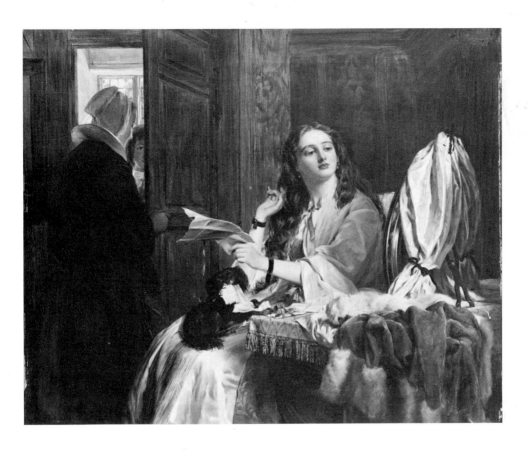

were, indeed, one of the most delightful forms of folk-art. What a pity they have become so debased!

I have not discovered that Horsley lent his decorative talents to the commercial production of Valentines, but he was clearly interested in them, and, as it happened, it was actually he who designed, in 1846, the first of what became the Valentine's chief commercial competitor, the Christmas Card.

Wolverhampton Art Gallery

[51]

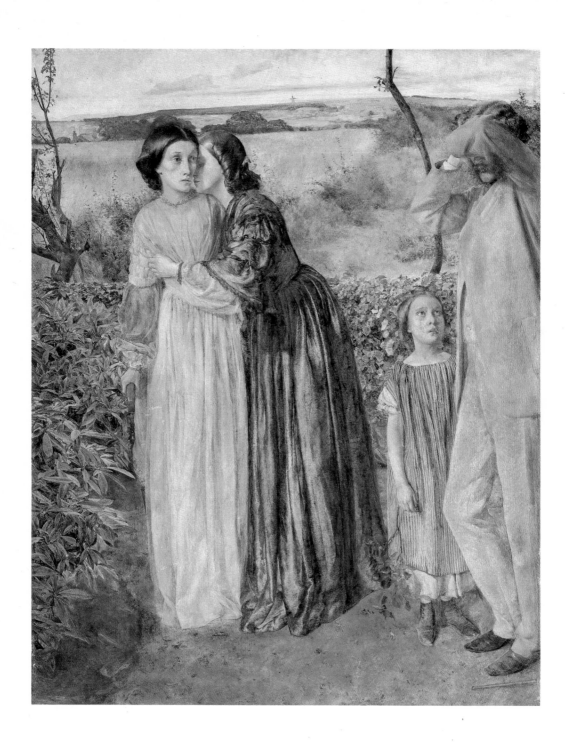

TOO LATE, 1859 *William Lindsay Windus*

OR ME, AND PROBABLY THE THOUSANDS of viewers who have puzzled over it since it was first exhibited at the Royal Academy in 1859, this has always been one of the most baffling of 'problem pictures'. The dramatic postures and agonized expressions of the cast are given an enigmatic edge by the implications of the title.

The artist spent many months painting the picture, and a friend who noted its slow progress wrote to Ford Madox Brown: 'He is more fastidious than ever; on the hair of one head he has spent four weeks in time and three pounds in money for a sitter, and it is not yet finished.' Later he wrote: 'But what he has done is beautiful in all eyes but his own.' At one stage Windus considered it 'unbelievably bad', and made up his mind 'to be slaughtered'.

Sure enough, when it was hung in the Royal Academy Ruskin wrote: 'Something wrong here; either this painter has been ill: or he has sickened his temper and dimmed his sight by reading melancholy ballads.' Windus was so discouraged that he retired into obscurity. Thirty years later Ford Madox Brown took a different view from Ruskin's. Describing 'Too Late' as 'intensely pathetic', he interpreted its meaning in simple terms: 'It represented a poor girl in the last stage of consumption, whose lover had gone away and returned at last, led by a little girl when it was "too late". The expression of the dying face is quite sufficient – no other explanation is needed.'

There are those who think a little more explanation *is* needed. Jilted girls didn't invariably contract tuberculosis, even in Victorian times. However distressed the returned lover may be, his dramatic gestures suggest guilt and remorse such as would hardly be induced by a mere failure to propose marriage. Why is the sister (or 'best friend') so emotionally involved? And what is the relationship of the pathetic little girl to the two people she has been at pains to bring together again? The man is conveniently hiding his face, but the features of the little girl and the invalid are not dissimilar. Are they mother and daughter? An unworthy thought perhaps; but I should be surprised if it didn't cross the minds of some Victorian viewers.

Tate Gallery

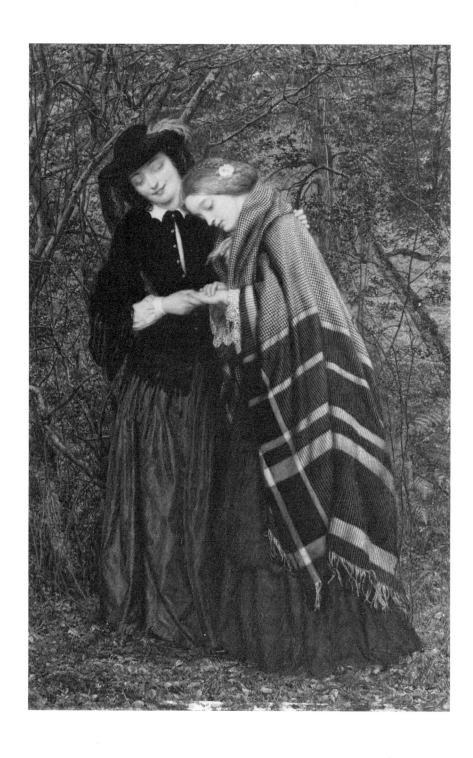

THE CONFIDANTE, 1857 *William Gale*

 HIS TINY LITTLE PAINTING, measuring only 9¾ by 6¾ inches, appears to be one of the few surviving paintings by a painter who nevertheless exhibited a hundred paintings at the Royal Academy. Gale was a little-known follower of the Pre-Raphaelite Movement, who spent much of his early life travelling in the Near East, Italy and Algeria.

This is a very happy illustration of what is a central character in almost all attachments of the heart – the faithful, understanding friend who can be entrusted with confidences and whose advice and guidance will always be wise, even if it is not always followed. When exhibited at the Royal Academy in 1857 the comment in the catalogue was: 'Friendship's shrine is Love's Confessional'.

Tate Gallery

(*Overleaf*): THE LAST EVENING, 1873 *James Tissot*

 NE OF THREE modern conversation pieces exhibited at the Royal Academy in 1873, this is among several Thames-side scenes painted by Tissot between 1872 and 1876. Several were painted aboard the *Arundel Castle* whose captain, John Freebody, had got to know Tissot soon after his arrival in London. The captain's wife and her brother, Captain Lumley Kennedy, served as models for the pair on the right.

The theme of imminent departure is complicated by the contrast in expression between that of the lover, who is the ship's mate, and that of the woman. The lover is staring fixedly at her, with obvious longing, whilst she stares into space reflectively. It has been suggested that their relationship is as tangled as the criss-cross rigging in the background, and it all hangs on the attitude of the woman who, in contrast to that of the mate, appears to be more listless than urgent or distressed. As in others of Tissot's paintings the mood is transient and equivocal, with a strong suggestion that the last evening has something final about it. That this effect was achieved with unprofessional models, who were all related or socially acquainted with one another, is a testimony to Tissot's entrepreneural skill. The theatrical element is increased by the presence of an audience: the ship's captain talking to the old man who is the woman's father, and the pert young girl who is clearly amused by the relationships of her elders. *City of London Art Gallery*

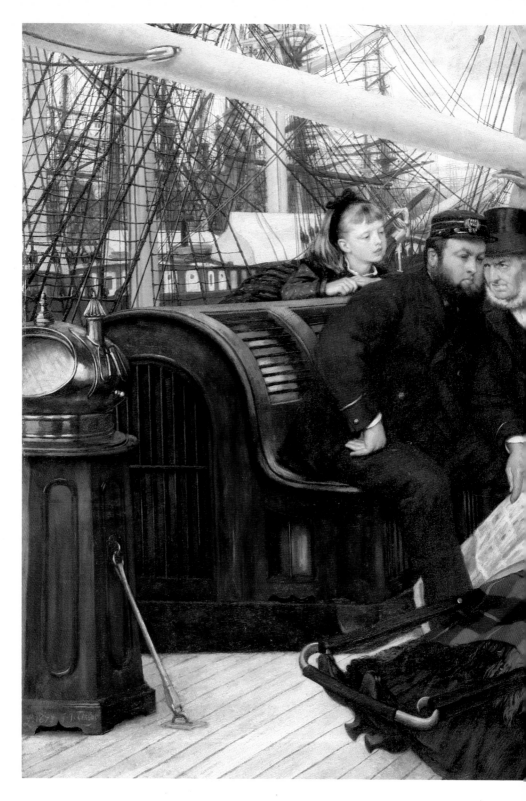

THE LAST EVENING: *See preceding page*

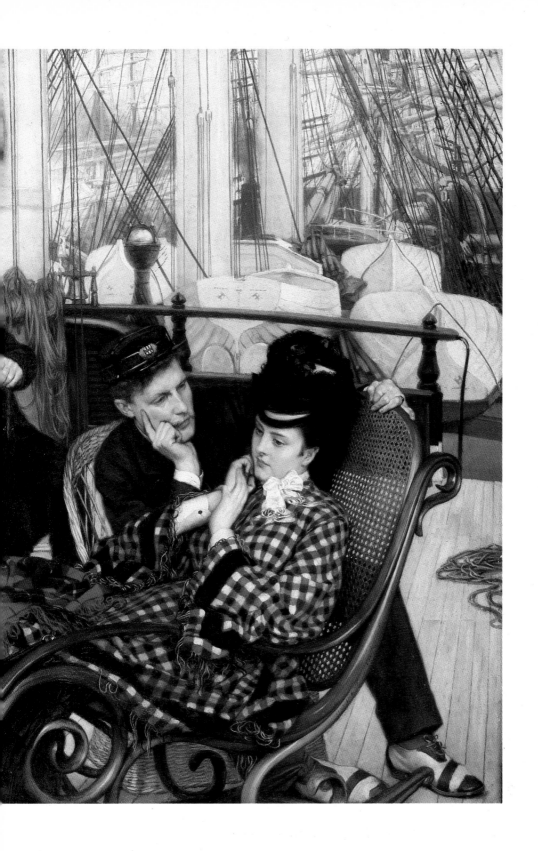

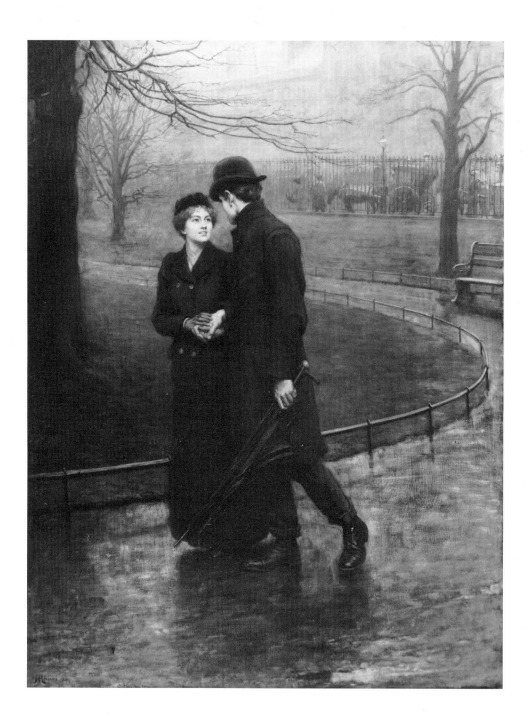

THE GARDEN OF EDEN, 1900 *Hugh Goldwin Riviere*

 ISSOT HAD RECENTLY SHOWN Londoners that it is relatively easy to create dramatic pictorial situations out of equivocal or complex emotional relationships which provoke speculation or discussion. Possibly this faculty derived from Tissot's Gallic ancestry. It is much more difficult to engage the interest of viewers in a perfectly straightforward portrayal of emotional fulfilment and happiness.

Perhaps it is not entirely fanciful to attribute Hugh Goldwin Riviere's delightful success in this simpler but yet more demanding task to the fact that despite his foreign-sounding surname he was as British in his outlook as had been his father, who devoted much of his life to studies of dogs. Fidelity is a word that Riviere would have understood.

The product of this decent conventional British outlook is so decent and conventional as to stand out in an art gallery like an old-fashioned family photograph. I find this well-posed and ultra-realistic painting of a happy couple in love heart-warming, and in its simplicity distinctly original. It is significant that it was exhibited in the Royal Academy in the first year of the twentieth century. The clothes and general turn-out of the couple are much more Edwardian than Victorian. The length of the young woman's skirt is exactly in period, and her relatively short hair and charming close-fitting cap are such as might have been worn by an early suffragette. Her open lips and eyes express a candour and love that go far beyond a downcast Victorian reticence.

Her escort, with his curly-brimmed bowler hat, his unfurled umbrella, his trouser legs rolled up to avoid the rain, and his laced-up boots, might be taken as the prototype of what is today popularly known as a Young Fogey.

I wish I could identify the corner of the park where the pair are walking, ignoring the rain, but my guess is that it is on the northern edge of Regent's Park, not far from the address in Finchley Road from which Hugh Goldwin Riviere submitted his early paintings to the Academy. The scene is so typical of a London park of the period, with the high railings bordering the street where the hansom cab is awaiting hire beneath the gas lamp, and the low railing round the pathway to keep pedestrians off the grass, that it makes the title of the painting really very moving in its gentle irony.

City of London Art Gallery

[59]

For Better, For Worse

FOR BETTER, FOR WORSE, 1881 *William Powell Frith, RA*

N HIS AUTOBIOGRAPHY Frith was at pains to explain the circumstances of this painting, to which, he said, he 'was prompted by seeing an almost identical realization of it in Cleveland Square'. The church in the background resembles Christ Church, Lancaster Gate, a few hundred yards away. Frith mentions the street boys being kept back by a policeman 'with an unnecessary display of force, a servant on her way to post a letter, an Italian boy with a monkey, a Jewish clothesman' (to whom the artist had to lend some old clothes before he sketched him), and the 'last and best part of the picture, a group of beggars who approach from the street, the man, his wife and children illustrating the latter part of the title'.

Somehow I question those last few words. The woman, conspicuously holding a child in her arms, is the most dramatic element in the picture, and I see no evidence that she is a beggar. I venture to advance the theory that she is present out of curiosity to see what sort of lady the gentleman is marrying, carrying in her arms what was usually described as 'a shameful bundle', for which the gentleman had some responsibility.

If there is any truth in this possibly fanciful interpretation you may ask why Frith would introduce so disturbing an element. Could it perhaps reflect a secret in the painter's life of which the world at large was totally unaware? Since the early eighteen-fifties Frith had lived with his wife and their ten children at 10 Pembridge Villas, only a short walk away from Cleveland Square. Just a mile away, in Oxford Terrace (now Sussex Gardens) Frith had another establishment, where his mistress, Mary Alford, bore him seven children before his wife died, in the year when 'For Better, For Worse' was painted, and Frith made 'an honest woman' of his mistress.

It is not surprising that it took Frith the whole of the year 1861 to complete the 'incessant work', as he describes it, involved in the painting of his masterpiece, 'The Railway Station'. This obviously called for constant visits to Paddington Station, which was conveniently less than a quarter of a mile from Oxford Terrace.

The full facts of this topographical coincidence are given in Jeremy Maas's entertaining book about *The Princess of Wales's Wedding* (1977).

Forbes Magazine Collection

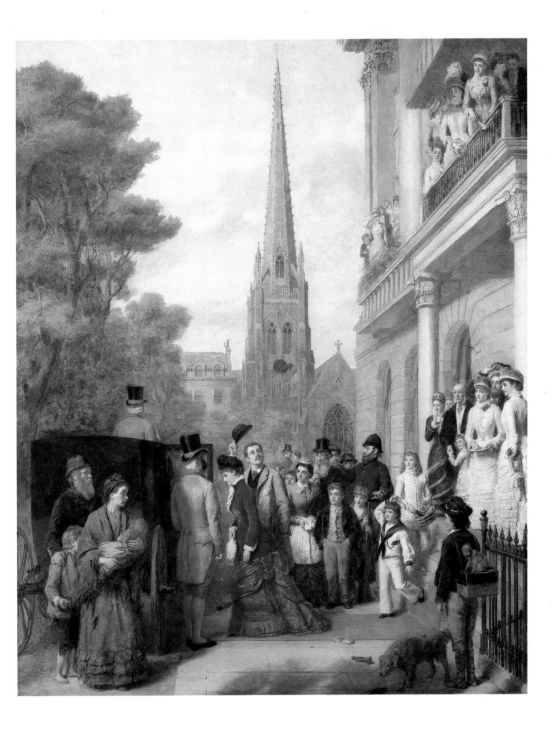

SIGNING THE MARRIAGE REGISTER, 1895 *James Charles*

E XHIBITED AT THE ROYAL ACADEMY in 1895, this was an example of a painting by one of the 'progressive' painters, including Sargent, Steer, Stanhope Forbes, Tuke and Bramley, who set up the New English Art Club in 1886. They now appear conventional but they were the *avant garde* who later formed the group known as London Impressionists.

Though this, by its subject matter, ranks as a narrative painting, the grouping and composition show a much greater realism and a more representative class setting than was shown in similar subjects painted by such earlier artists as Frith and Hicks. The father and mother are clearly working-class people, the father wearing a traditional villager's smock with a white favour, and the mother a bonnet such as the widowed Queen would have approved. A pleasantly informal touch is the father inadvertently standing on the edge of the bridal gown.

All the women guests are wearing what almost appears to be a wedding uniform, with swept-back hair and flowers behind their ears. The handsome bearded groom wears a rosette but is not ashamed to proclaim that he is only an able-bodied seaman. Though the artist was a Paris-trained 'progressive' this delightfully unpretentious group would have been completely in keeping over the mantelpiece of an ordinary English cottage or farmhouse.

Bradford Art Gallery

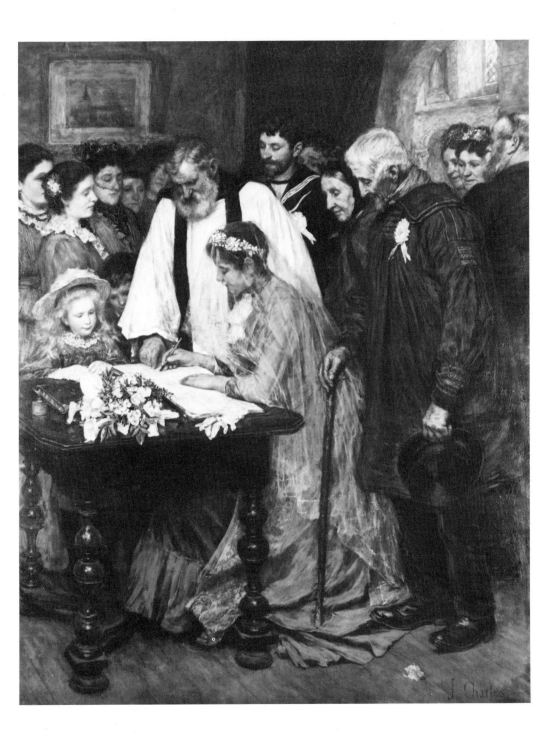

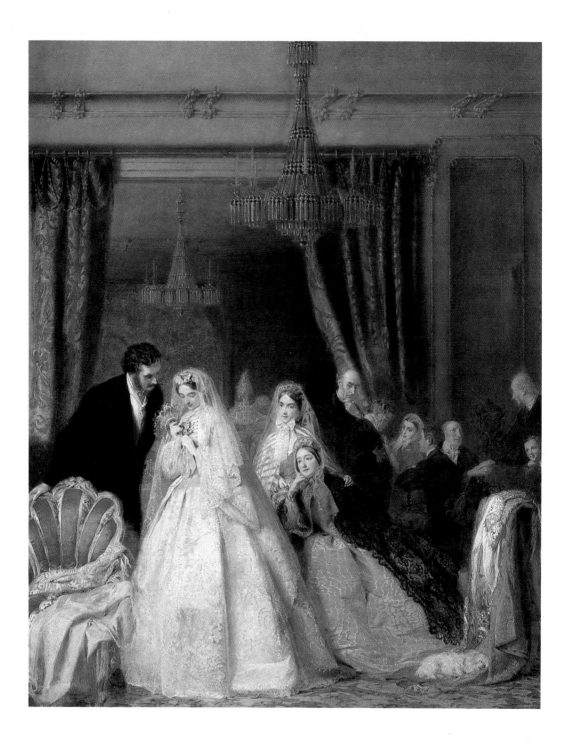

CHANGING HOMES (*Detail*), 1862 *George Elgar Hicks*

 HIS DETAIL FROM A WIDE CANVAS, measuring 152.4 × 91.5 centimetres, shows a bridal couple on their return from church to the house of friends or relations where the wedding reception will be held. The social setting is clearly on a much higher level than that of the wedding recorded on page 63. It would seem that Hicks found his inspiration for this painting – as he did for his well-known crowd scenes at the General Post Office and Billingsgate – in the pages of *Twice Round the Clock* by George Augustus Sala, a book depicting scenes of London life. This scene in the book was called 'Marriage in High Life'.

Sala wrote: 'How I could expatiate on the appearance of the beauteous bride, her Honiton lace veil, her innumerable flounces; and her noble parents, and the gallant and distinguished bridegroom!' Commentators on Hicks's version of the scene were less ecstatic. The room is probably based on one that belonged to the Hicks family at 36 Kensington Park Road, which had two first-floor drawing rooms separated by folding doors and 'gilt moulding round top and base of room'. The lack of family portraits and inherited furniture indicated that the family, like the Veneerings in Dickens's *Our Mutual Friend*, were *parvenus*. Gilded furniture – like the new rococo revival chair with its aniline-dyed magenta stripes, and white and gold plaster-work, was very popular with newly-rich Victorians.

So much for the setting. As regards the artistic treatment, *The Times* found the painting, when shown at the Academy in 1863, 'intensely vulgar. Mr Hicks's pictures are precisely of the kind to please unformed tastes. They are pretty, skilful and highly finished; all the men have regular features, lovely complexions, irreproachable whiskers; all the women are smooth-skinned, pink-cheeked, large-eyed. Great prominence is given to millinery, and every face, if sentimental, is excruciatingly pretty.'

What can a twentieth-century commentator add, except that it adds up to a picture which that shrewd judge, the late Queen Mary, would probably have described as 'very amusing'?

London: The Geffrye Museum

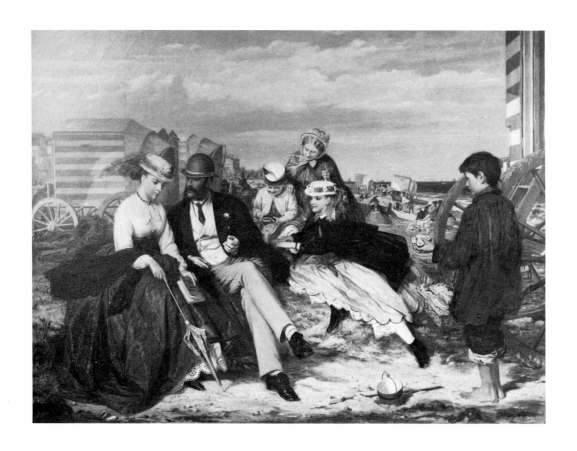

ON THE BEACH, 1867 *Charles Wynne Nicholls*

EA-BATHING HAD BEEN INTRODUCED as a recreational activity in 1754 by Dr Richard Russell, who prescribed it as a cure for most ills, and was partly responsible for the development of Brighton as a resort by the Prince Regent. The vogue spread in Victoria's reign to Ramsgate (celebrated by Frith), Margate, Weymouth (celebrated by Constable), Scarborough and many other 'spas'. This elegant conversation piece was acquired in this century by a Scarborough hotelier, Tom Laughton, brother of the actor Charles. He was a great collector of Victorian paintings before they became fashionable. It has now passed to the Scarborough Art Gallery, though in fact the scene is not Scarborough but Margate. Against a background of bathing machines a family is engaged not in taking health-giving exercise, but what looks more like afternoon-tea on the vicarage lawn. *Art Gallery, Scarborough*

[66]

THE HOLYDAY, *or* THE PICNIC, *c.*1876 *James Tissot*

 ARIOUS MINOR PUZZLES and visual jokes are offered by this charac-
teristic painting of leisured life amongst the *jeunesse dorée*. Its title,
'The Holyday', is a play on words embodying a joke about the halo-
like boating caps worn by the men. In fact they are not boating caps,
but cricket caps, ringed with the I Zingari colours, probably because
the picture was painted in the garden of Tissot's house in Grove End
Road, near Lords Cricket Ground. There are several other visual jokes, such as the
odd layout of the knives and forks, repeating the patterns of the chestnut leaves above.
The four men posed round the edge of the pond represent four stages of manhood: the
bachelor leaning against the tree; the suitor in the background; the man in the centre
between two women, one of whom may be his wife, the other his mistress; and, on the
extreme left, a widower with his child and his mother. *Tate Gallery*

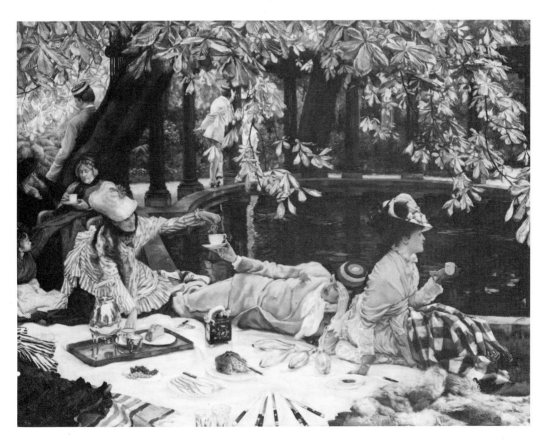

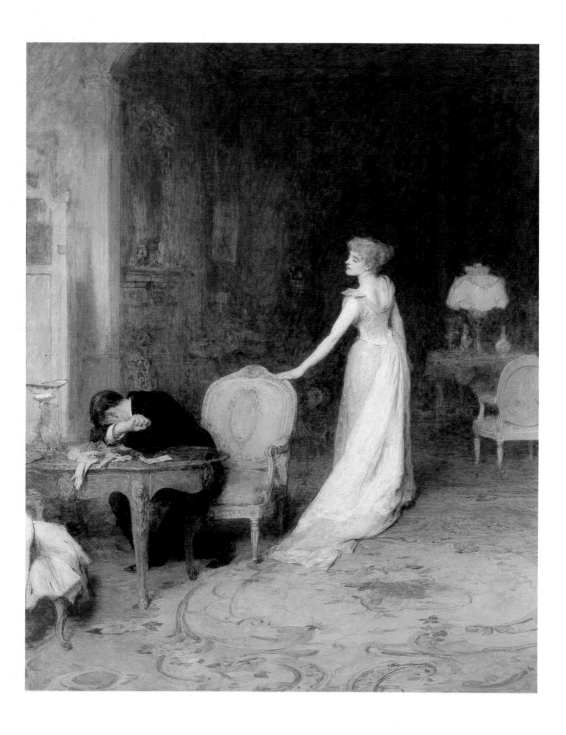

N HIS INTRODUCTION to the retrospective exhibition of Orchardson's work in 1972 Mr William R. Hardie wrote that in his heyday, in the eighteen-eighties, 'ingenuity was the rage at the Academy . . . and Orchardson, although without cynicism, had a happy knack of choosing tales which suited his audience. . . . His subject-matter has a certain underlying unity which comes from the artist's preoccupation with moments of psychological drama, often set in calm or luxurious surroundings, of which the actors seem to be the prisoners, or whose stability is momentarily troubled by their mental anguish'.

'Trouble', which was exhibited at the Royal Academy in 1898, is a masterly example of Orchardson's preoccupation with 'psychological drama'. It is, however, by no means easy to interpret the theme of the painting. Most viewers assume that it represents a marital disaster, for which the husband is responsible, and for which his wife is rebuking him, and for which she is about to leave him. (Why else are her gloves, thrown down on the Empire table, so significant an element in the painting?)

No so, said the painter. His daughter, in her biography of her father, records going to his studio to look at 'Trouble' and asking her father whether the man's distress were caused by disgrace or misfortune. Her father replied: 'I think it is money trouble.' His daughter asked 'Has he been cheating?' 'No, just loss, I should say.' 'But how,' asked his daughter, 'can money, mere money, cause such trouble?' The painter replied, tamely, 'Well he can't give to his wife as usual . . . that would cause him distress.'

This seems to me a quite inadequate explanation; and I should be very surprised if this was what the painter really had in mind when he painted the picture. He would not, of course, be entirely candid in his explanation to a cherished daughter. Obviously the only true explanation is to be sought in the expression on the wife's face. The daughter said: 'The wife shows compassion?' Could it not equally well be contempt?

Orchardson was, without question, a very upright, kind and good man, devoted to his family. But it does not necessarily follow that he did not harbour in his subconscious mind the same secret fears and apprehensions that were common to a large part of the strait-laced Victorian bourgeoisie. I consider that 'Trouble' is one of the great problem pictures of its era. Its title tells one everything . . . and nothing!

The Fine Art Society

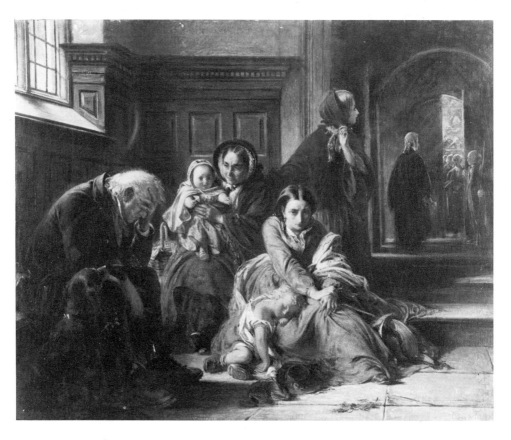

WAITING FOR THE VERDICT, 1857 *Abraham Solomon*

EXHIBITED AT THE ROYAL ACADEMY in 1857, this and its sequel, 'Not Guilty', shown in 1859, became famous overnight. The critic of the *Art Journal* wrote: 'These two works have found more favour with the public than, we think, any that have gone before. The first is an earnest and profoundly pathetic passage of art. . . . The despair of the father, the bitter grief of the wife, the unspeakable distress of the mother, are set forth in terms the most touching.' The public response to the painting is demonstrated by the fact that when it was submitted to the Liverpool Academy for an annual prize it was the painting generally favoured, and only a group of Pre-Raphaelite partisans on the Academy jury managed to keep it in second place behind Millais's *The Blind Girl*.

Ashton Bequest, Tunbridge Wells Art Gallery and Museum

(*Overleaf*) THE FIRST CLOUD, 1887 *Sir William Quiller Orchardson, RA*

OWARDS THE END OF THE NINETEENTH CENTURY, as I mentioned in my note on the same artist's 'Trouble' (page 69), well-known Academicians vied with one another to present studies of men and women in somewhat problematic states of mental agitation. There was keen competition to produce what would be regarded as 'the problem picture of the year'. Usually there was little problem about it: the theme was an easily recognizable one of fatal illness, adultery, domestic discord or financial disaster.

Sir William Orchardson and the Honourable John Collier were the two outstanding 'problem' painters of their day. Orchardson was by far the better painter of the two, and was something of an innovator in his use of thin, transparent brushwork and subdued colouring, and in the wide spacing between figures that is a personal characteristic of his work. It is a mystery why he chose to become famous as a popular painter of scenes of domestic discord. His family and his home were the central elements in his private life. There is no evidence of his having kept a mistress, or, like Frith, supporting two homes. His daughter, to whom he was deeply attached, regarded his famous pair of paintings of a 'Mariage de Convenance' as attempts by him to depict the opposite of his own calm and placid domestic environment. It may well be that the thought of any disruption of it may have lurked as a hidden fear at the bottom of his mind, a nightmare such as was experienced by many other eminent Victorians of the utmost integrity.

As far as I can discover, he never gave expression to his fears or nightmares except, implicitly, in his problem paintings. When asked by his daughter if art should be didactic and if subject were important, he answered that what appealed to him personally was 'the dramatic moment'. In no painting is this more evident than in 'The First Cloud', which calls for no explanation, but explains itself completely in the posture of the glaring husband, his back to the fireplace, his hands thrust deep into his pockets, and his wife, distanced to achieve maximum dramatic effect, flouncing towards the gap in the curtains.

The painting was caricatured by *Punch*, with a drawing of the husband, in a painter's smock, addressing a departing model (the wife) with the words:

> *Yes, you can go; I've done with you, my dear.*
> *Here comes the model for the following year.*
> *Luck in odd numbers – Anno Jubilee –*
> *This is divorce Court Series Number Three.*

National Gallery of Victoria, Melbourne, Australia

[71]

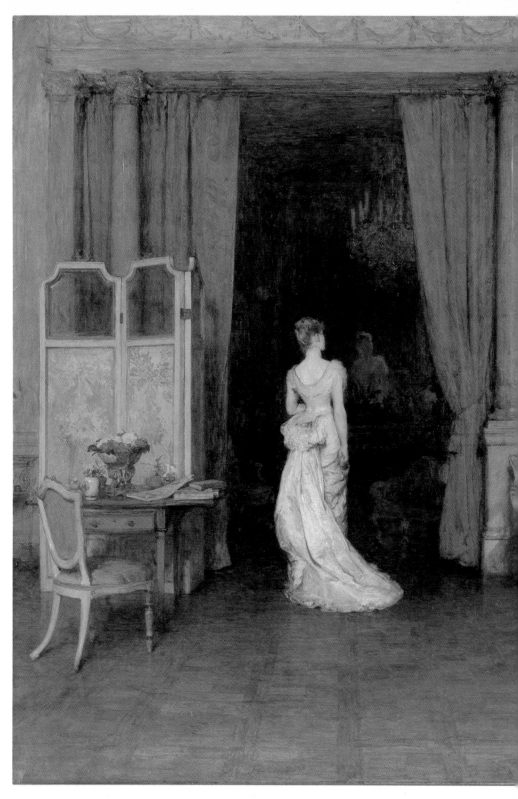

THE FIRST CLOUD: *See preceding page*

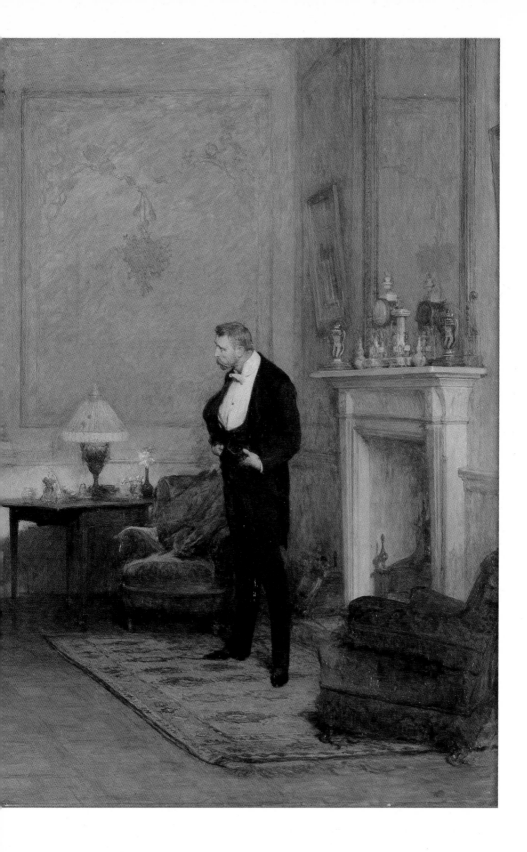

THE LAST DAY IN THE OLD HOME, 1861 *Robert Braithwaite Martineau*

ARTINEAU, WHO WAS A PUPIL OF HOLMAN HUNT and shared a studio with him, is believed to have taken ten years to complete this famous painting. As Jeremy Maas wrote in his *Victorian Painters*: 'In its rich Pre-Raphaelite colouring and overloaded anecdotalism it is the apotheosis of Henry James's three-volume novel, and explains his rage when he described this sort of picture as "an almost touching exhibition of helplessness, vulgarity and violent imbecility of colour".'

That is one way of looking at it, but for us today, as for the average Victorian viewer, the painting certainly provides what might vulgarly be described as 'a good read'. The profligate young Man About Town, who has gambled away his wealth on the horses, shares the last bottle of champagne with his foolishly doting son in the ancestral home, despite the disapproval of his nagging wife. Meanwhile his old mother is trying to negotiate with the auctioneer's agent the sale of the house and its contents. As usual with the Pre-Raphaelites, the room is chock-a-block with symbolism: the racing print leaning against the sideboard on which is placed a triptych containing a carving of a crucifixion; the auctioneers' lot numbers; the Old Master family portrait on the wall above a mediaeval tapestry; the ancestral suit of armour, and the visor and breastplates over the Jacobean chimneypiece; the empty decanter; the newspaper open at the advertisement for 'Apartments'; and the Christie's catalogue on the floor.

Change and decay in all around we see. In a few months' time the splendid Jacobean mansion will be acquired by a newly-rich ironmaster from the North, and the neer-do-well may be following the example of the fellow gambler who is seen on page 77 fleeing the country. A cautionary tale that strikes at the heart of Victorian complacency.

Tate Gallery

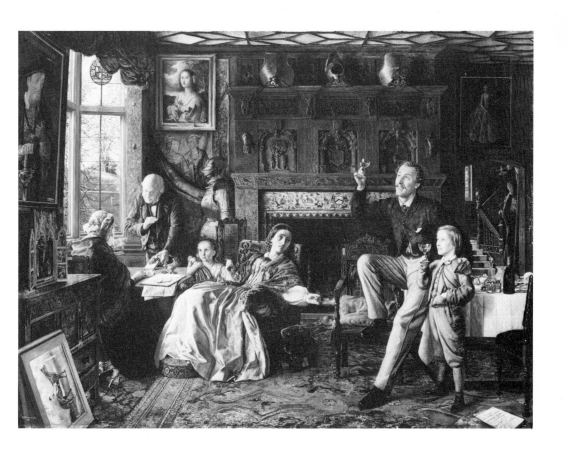

E DO NOT KNOW FOR CERTAIN the date of this painting but it could perhaps have been inspired by Ford Madox Brown's 'The Last of England' (1852–5). 'The Escape', however, is not a study of emigration; it is evidently a cautionary tale about a man who has come a cropper on the turf – see the copy of *Bell's Life in London* lying on the deck below his knee: this was the favourite reading of Soapy Sponge in Surtees's novel. Now he is fleeing from his creditors, making the traditional escape to the Continent (Calais, as a rule) with his attractive young wife, who, to judge by her expression, is already beginning to regret having married a compulsive gambler.

The envelope on the woman's lap, with its penny red Victorian stamp, is a clue which we can interpret as we please. Did the letter it contained bring news which made them realize they must clear out at once? Or was it a passionate appeal from her parents to leave the man? Perhaps the latter, because she certainly would not wish him to see it; so that is why she is clutching at it so firmly. And is the mud on the man's boots and trousers meant to show that they had to leave in a hurry?

The two main figures are admirably painted. He is a typical Victorian ne'er-do-well, the 'villain' of a Whyte-Melville novel. The wife is attractive enough to inspire pity. She is also attractive enough to make me question the opinion of the owner of the picture that she is his *wife*. As evidence he quotes her wedding ring. (But didn't Victorian ne'er-do-wells carry an assortment of wedding rings for eventualities like this?)

The members of the crew are not quite so convincing. The man at the wheel is awkwardly placed, and surely as helmsman he should be looking ahead. The one with the telescope, looking to see if they are being pursued, appears to be balancing it on his colleague's forearm. Altogether the seamanship exhibited has invoked stern criticism from two practical sailors to whom I showed a photograph of the group. But the details are excellently painted, and I for one wish the couple '*Bon Voyage!*', though they don't deserve it.

Private Collection

[76]

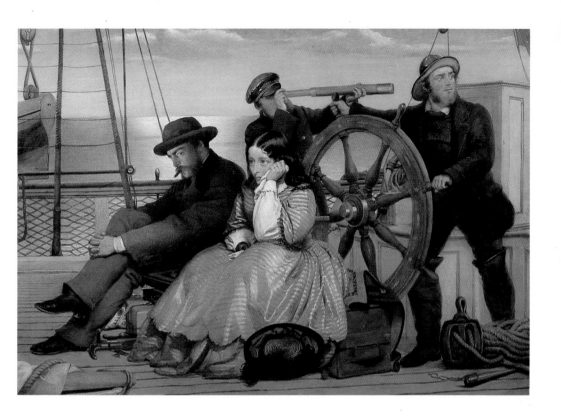

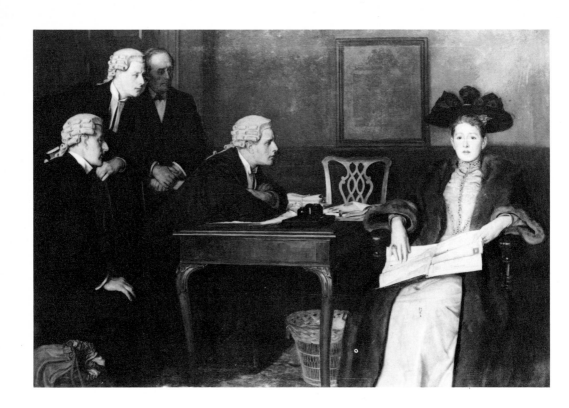

DEFENDANT AND COUNSEL, 1895 *William Frederick Yeames, RA*

'**A**ND WHEN DID YOU LAST SEE YOUR FATHER?' by W. F. Yeames (1878) is probably the most famous of all narrative paintings; so much so that its title is enshrined in the *Oxford Dictionary of Quotations*. Yet when his 'Defendant and Counsel' was exhibited in the Royal Academy seven years later, and Yeames was bombarded with entreaties to 'explain it', he protested that all he had in mind was 'achieving a certain pictorial effect'. There may have been some truth in that, for Yeames was technically an accomplished and ingenious painter and he claimed that his short-sightedness enabled him to make unusual compositions by use of emphatic tonal contrasts of light and shade.

Such aesthetic argument, however, was of no interest whatever to the viewing public. One woman wrote to Yeames to say she could not sleep at night for wondering what the poor young lady in the picture had done. And Cassell & Company offered a cash prize for the best solution put forward, inviting Yeames himself to judge the entries. The solutions proposed involved the lady defendant in cases ranging from divorce to murder.

The *Strand Magazine* took up the question again, no less than thirty years later. Yeames once more protested that he had only been interested in certain pictorial effects, though he admitted that he had chosen as the scene of his painting one of the consulting rooms attached to the law court where counsel and clients could meet for discussion. Then, surprisingly, he unburdened himself. 'My only idea when painting the picture,' he wrote, 'was to depict the eagerness of counsel to obtain from the lady defendant information on a point on which the defence depended, and the unwillingness of the lady to enlighten them, lest, by doing so, she should compromise a friend of hers.' Well, well, well! Talk of a problem picture? Here's a splendid initial scenario! All you have to do is to fill in a few details – to Counsel's satisfaction.

Yet one has to admit that the triangle of lawyers' wigs, pointing past the complex carving of the Chippendale chair towards the tense posture of the defendant, does indeed make a masterly visual pattern, and maybe that *was* all that Yeames was aiming for.

City of Bristol Museum and Art Gallery

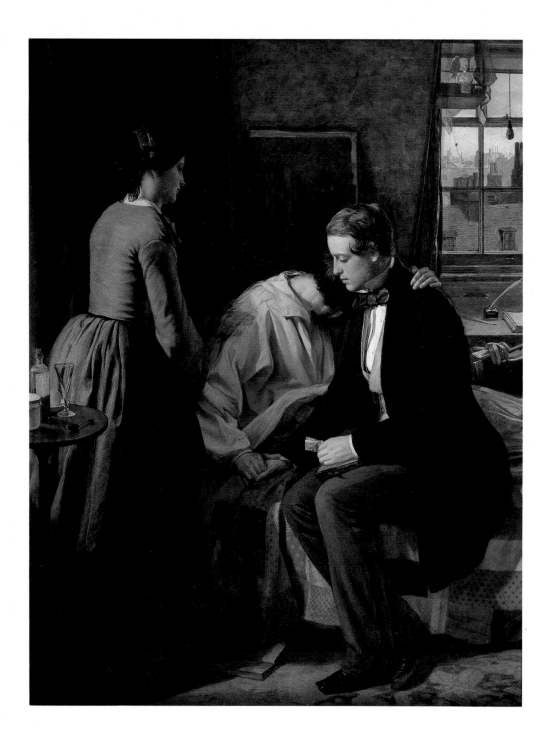

Tears, Idle Tears

PUTTING IT IN COLLOQUIAL TERMS, there was nothing the late-Victorians enjoyed as much as 'a good cry'. It was, presumably, a relief from the robust self-confidence that characterized English bourgeoisie throughout the greater part of the era. As G. M. Young wrote in his classic book on *Victorian England*: 'To put money in the savings bank was in 1840 as good an ideal as could be set before a man. To pursue it gave him a rank as a citizen . . . and a share in a solid civilization. If thereto the State added a safe and healthy workshop, a decent house, and a good school, what more was there left to think of?'

Human nature being what it is, there was much else to think of, especially in the silent watches of the night: sickness and sorrow, death and disaster, and, above all, disgrace. These unspoken fears found a ready outlet in melodrama on the stage and in a vast outpouring of maudlin songs at the piano.

OLD SCHOOLFELLOWS, 1854 *Alfred Rankley*

G. M. YOUNG LISTED HIGH IN HIS PRIORITIES 'to put money in the savings bank'. Personal financial stability was an essential counterpart to the general stability of the state. Gambling was a cardinal sin, failure in business utterly reprehensible, bankruptcy the final disgrace. There was nothing so embarrassing for a prosperous man of affairs as to have to visit an old schoolfellow who had fallen, financially, by the wayside. It requires only a glance at the caller's exquisitely tied bow and elegant waistcoat, his manicured hand and his brilliantined hair, to know that he is one of the winners in life's stakes. He finds his old school chum living in what is no better than a garret. Beyond the symbolical canary in its cage is a prospect of slums.

The erstwhile school friend has evidently married without having a proper job. The abandoned pen and inkwell under the window indicate that he has failed as an author. And he has fallen sick. His old companion's visit reduces him to tears. Appropriately a copy of Cicero's *De Amicitia* lies on the floor.

Perhaps the handsome red-bound volume on the caller's knee is a volume of verse which the failed poet has paid a publisher to put on the market. At least it gives him a chance to offer the volume as a gift to his friend, so that the £5 note that is being pressed on him looks less like a charitable offering.

Private Collection

[81]

ERFECTLY PORTRAYING a characteristic Victorian widow, grieving over her husband's grave, in her black satin and bombazine, this realistic painting epitomizes – without sentimentalizing – the Victorian preoccupation with death. Christopher Wood, in *Victorian Panorama*, comments on the 'different scales of mourning laid down for children, parents, uncles, cousins, and even for relations by marriage. . . . In a large family the chances were that a woman might have to be almost continuously in some kind of mourning. It became an industry. Courtaulds founded their fortunes selling crape; Peter Robinson specialized in mourning clothes; there were other stores especially devoted to the sale of jet jewellery, black-edged letters, envelopes and visiting cards, black sealing-wax, and all the other paraphernalia.'

Queen Victoria set the fashion for widowhood with her mourning after Albert's death in 1861, which she maintained for over ten years; and for all her life thereafter she preferred to wear black. The cult of gloom was expressed by many Victorian painters, notably Frank Holl, whose 'No Tidings from the Sea' was eagerly bought by Queen Victoria. Dickens contributed generously to the death roll, with Paul Dombey and Little Nell, and Mrs Henry Wood's *East Lynne* was dramatized to great effect. Drawing-room ballads, like Thomas Haynes Bayly's 'She wore a Wreath of Roses', were always assured of an encore:

> *And once again I see that brow,*
> *No bridal wreath is there,*
> *The widow's sombre cap conceals*
> *Her once luxuriant hair*

The depths of maudlin sentiment were reached with a ballad whose authorship I have failed to find, but which includes the lines:

> *Why did they dig Ma's grave so deep?*
> *Why do they leave me here to weep?*

Walker Art Gallery, Liverpool

[82]

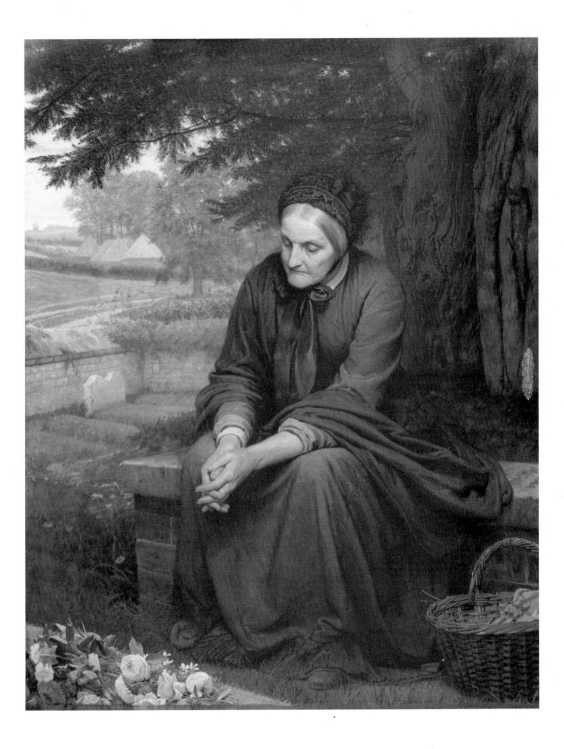

HOME FROM SEA, 1856–62 *Arthur Hughes*

 UITE A MYSTERY SURROUNDS the circumstances in which this painting, so carefully and effectively composed, was painted. It seems to have been exhibited at the Pre-Raphaelite Exhibition in Russell Place in 1857 under the title of 'A Mother's Grave'. Contemporary accounts, however, do not mention the figure of the sister, and she is not included in a drawing of the subject in the Ashmolean Museum, which has been dated as April 1857. It is assumed that Hughes added the girl after the first exhibition of the painting and before it was shown again at the Royal Academy in 1863, with the title 'Home from Sea'.

In a letter written to William Hale-White in 1901 Arthur Hughes wrote: 'It represented a young sailor lad in his white shore-going suit, cast down on his face upon the newly turfed grave where his mother had been put in his absence – his sister in black kneeling beside him: his handkerchief bundle beside – sunshine dappling all with leafy shadows – old Church behind with yew tree painted at Old Chingford Ch: Essex. . . . At the time I painted it my wife was young enough to sit for the sister: and I think it was like' (Tate Gallery Archives).

The landscape, which is an especially beautiful element in the painting, was apparently painted at Chingford in the summer of 1856. The painting is inscribed by the artist with the date 1862. Whilst accepting what the artist himself wrote about the painting one has to point out that the girl's cloak is not black but dark brown. The present title was chosen by the artist when the painting went to the Royal Academy.

Ashmolean Museum, Oxford

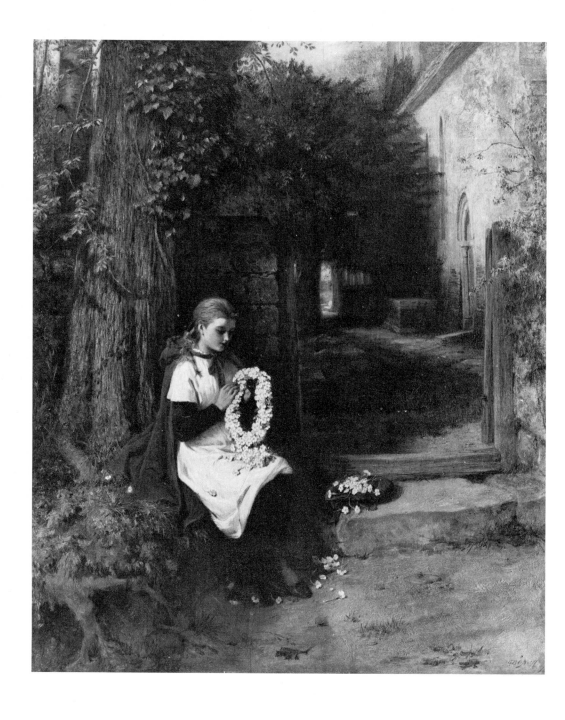

NOT FORGOTTEN, 1882 · *George Bernard O'Neill*

REATHS EPITOMIZED the Victorian concern with death and the graveyard. The laying of wreaths on anniversaries was a domestic responsibility, never to be overlooked. This charming and well-composed painting, with its almost Pre-Raphaelite treatment of the tree and ivy on the left, and the concentration of visual interest on the beautifully drawn figure of the girl, rises above the more anecdotal character of most of O'Neill's work. The girl is seated just inside the entrance to a churchyard somewhere in Kent, though it is not St Dunstan's, Cranbrook, the country town in Kent near which O'Neill lived in the little hamlet of Old Wilsley from 1859 to 1898. The fact that the wreath is being woven entirely of primroses suggests that it may not be a family wreath but a commemorative wreath to the memory of Lord Beaconsfield, who died in the year before this picture was painted, and whose death was for many years commemorated by Primrose Day.

Wolverhampton Art Gallery

(*Overleaf*) HER MOTHER'S VOICE, 1888 · *Sir William Orchardson, RA*

Upon his widowed heart it falls,
Echoing a hallowed time.

HIS QUOTATION WAS PRINTED in the catalogue of the Royal Academy exhibition in 1888. Sad but precious memories flood the mind of the widower as he listens to his daughter singing at the piano her mother's favourite songs. It is a typically tearful, but beautifully painted, example of late-Victorian art.

According to Orchardson's biography, written by his daughter, 'Her Mother's Voice' was painted in the drawing room of the James Adam house at 13 Portland Place where the painter lived from 1887 until his death. The room was papered with a patterned gold paper over which was superimposed a matte-white pattern of Orchardson's own design.

There is no autobiographical element in this painting. Orchardson's wife, to whom he was deeply devoted, outlived the painter by seven years. But 'His Mother's Voice' is a touching expression of the affection felt for her by a good, if somewhat sentimental, Scotsman, who was a master of his craft.

Tate Gallery

[87]

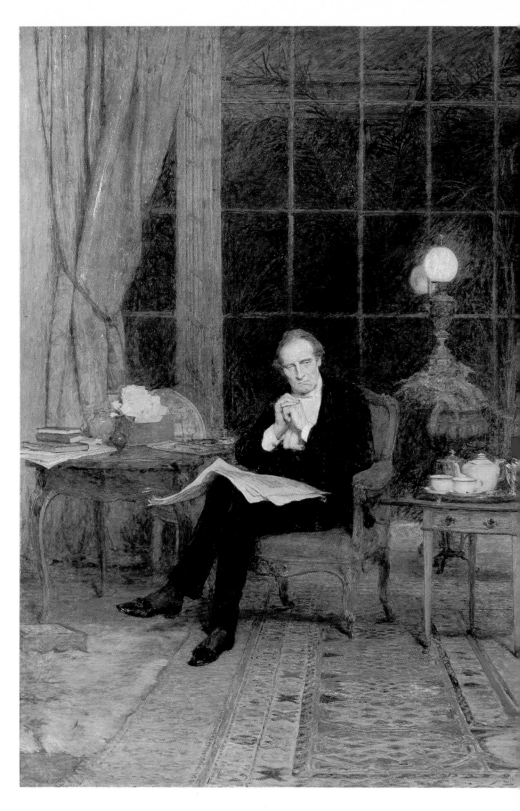

HER MOTHER'S VOICE: *See preceding page*

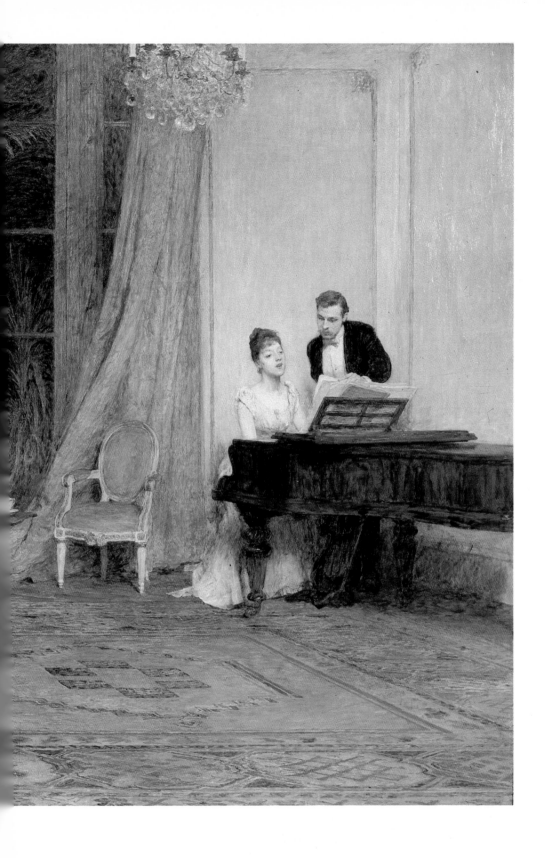

LOVE LOCKED OUT, 1890 *Anna Lea Merritt*

 HIS WAS THE FIRST PAINTING by a woman artist to be bought by the Royal Academy under the terms of the Chantrey Bequest, and it was regarded at the time as the first official recognition of the fact that women could compete successfully with men in painting. It was not merely for that reason, however, that it soon became enormously popular.

It was – and still is – regarded by many people as an allegory of frustrated, or forbidden, sexual love. This was because it was the third of what the artist herself described as paintings 'of that kind of subject'. The first, 'Camilla', was a large full-length nude which was painted as a study, with no idea of exhibition, but which the artist was persuaded to show at the Royal Academy in 1883. The second was called 'Eve' and was hung on the line in 1885.

The allegory of 'Love Locked Out', however, was completely misunderstood. Mrs Merritt, in an unpublished autobiography, of which a typescript is in the Victoria and Albert Museum in London, explained that the idea had been inspired, years before she painted the picture, as a memorial to her husband, the critic and restorer Henry Merritt, whom she married in 1877 and who died within a year. 'In my thought,' she wrote, 'the closed door is the door of the tomb. Therefore I showed the dead leaves blowing against the doorway and the lamp shattered. 'The light in the dust lies dead,' another broken lute. . . . For years I refused to have it copied, for which entreaties were innumerable. I feared people liked it as a symbol of forbidden love, while my Love was waiting for the door of death to open and the reunion of the lonely pair.'

The image of Cupid was conjured up, in typical Victorian style, by sorrow, not by sex.

Tate Gallery

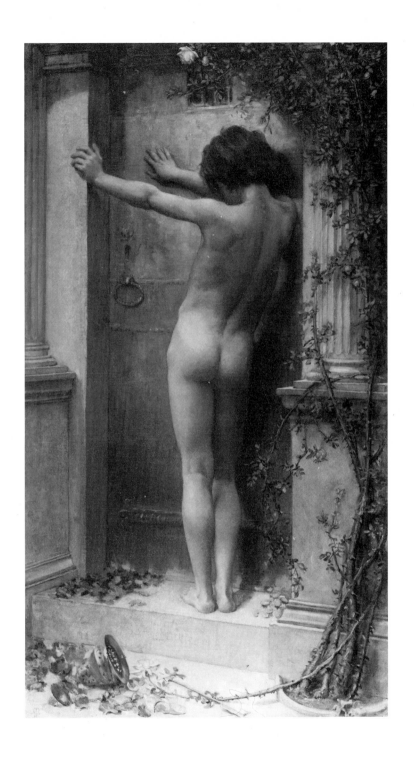

Dumb Friends

ANIMAL ART is one of the chief glories of English painting, with a continuous history that runs from the seventeenth-century Francis Barlow, through the eighteenth-century 'primitives' such as the members of the Sartorius family, James Seymour and John Wootton, then to the masters, George Stubbs, Sawrey Gilpin, James Ward and Ferneley, down to Munnings in the twentieth century. Until the Victorian period, however, the emphasis in almost all paintings of animals was on sporting art, which involved animals concerned with field sports, such as horses, hounds, foxes, deer, hares and wildfowl. Patronage of animal painters came almost entirely from landed gentry and the squirearchy.

Although hunting, shooting and fishing remained prime recreations of the upper classes throughout the nineteenth century the rise of a prosperous middle class led to the promotion of domestic pets to membership of the family circle, as distinct from their normal habitat in kennel and stable. This particularly applied to the dog, who, to quote a biographer of Landseer, was elevated to 'something that closely approximates to human nature in its generous sympathies'.

SYMPATHY, 1877 *Briton Riviere, RA*

'YMPATHY,' *The Graphic* wrote, 'is one of the most perfect linkings of human and animal in the bond of common feeling that was ever put on canvas'. And so distinguished a critic as Ruskin wrote: 'It is long since I have been so pleased in the Royal Academy as I was by "Sympathy". The dog is uncaricatured doggedness, divine as Anubis, or the Dog-star; the child entirely childish and lovely, the carpet might have been laid by Veronese. A most precious picture in itself, yet not one for a museum. Everyone would think only of the story; everybody [would] be wondering what the little girl had done, and how she would be forgiven, and if she wasn't how soon she would stop crying, and give the doggie a kiss, and comfort his heart.'

The Spectator named Riviere as 'the only animal painter in England who has taken the place of Landseer [who had died in 1873]. Riviere has surpassed Landseer in his own way, for he has given feeling to his animals, and yet kept them strictly within their own nature.' *The Royal Holloway College*

THE OLD SHEPHERD'S CHIEF MOURNER, 1837 *Sir Edwin Landseer, RA*

HE 1837 ROYAL ACADEMY opened at the beginning of May, and on June 20 Victoria succeeded to the throne. Landseer's first popular success, therefore, was his first exhibited in Victoria's reign. 'The Old Shepherd's Chief Mourner' may to-day be scoffed at as an embarrassing exercise in sentimentality, but when first exhibited it drew comments from sophisticated critics that indicated how real its emotional appeal was to contemporary viewers. For instance, in the first volume of *Modern Painters* (1843) Ruskin wrote about it at length, describing it as 'one of the most perfect poems or pictures (I use the words as synonymous) which modern times have seen'.

Ruskin continued: 'The exquisite execution of the glossy and crisp hair of the dog, the bright sharp touching of the green bough, the clear painting of the wood of the coffin and the folds of the blanket, are language – language clear and expressive in the highest degree. But the close pressure of the dog's breast against the wood, the convulsive clinging of the paws, which has dragged the blanket off the trestle, the total powerlessness of the head, laid close and motionless, upon its folds, the fixed and tearful fall of the eye in its utter hopelessness, the rigidity of repose which marks that there has been no motion nor change in the trance of agony since the last blow was struck on the coffin-lid, the quietness and gloom of the chamber, the spectacles marking the place where the Bible was last closed, indicating how lonely has been the life, how unwatched the departure, of him who is now laid solitary in his sleep – these are all thoughts – thoughts by which the picture is separated at once from hundreds of equal merit, as far as mere painting goes, by which it ranks as a work of high art, and stamps its author, not as the neat imitator of the texture of a skin, or the fold of a drapery, but as the Man of Mind.'

'The Old Shepherd's Chief Mourner' was bought by the great collector of English Victorian paintings, John Sheepshanks, who presented it to the South Kensington Museum, now the Victoria and Albert Museum, in 1857. It was first engraved, by B. P. Gibbon, in 1838 and became one of the best-selling prints of the century. In 1837 Landseer painted a pendant entitled 'The Shepherd's Grave', which was not exhibited until the show of Manchester Art Treasures in 1857.

Victoria and Albert Museum

BOSOM FRIENDS, 1881 *Charles Trevor Garland*

HIS DELIGHTFUL PAINTING was illustrated some years ago as the work of an unknown painter, and was given the purely descriptive title: 'At the Railway Station'. It was not until the present owner read the words 'Manager C. T. Garland', painted on one of the posters in the background of the picture, that he suspected that this might be in fact the name of the painter. So, indeed, it was. Charles Trevor Garland was a painter who specialized in paintings of children and dogs; he exhibited twenty-seven paintings at the Royal Academy between 1874 and 1901, and sixteen at the Society of Artists. It is believed that the painting reproduced here was one shown at the Society of Artists in 1881, and again at the Royal Academy in 1890, with the title 'Bosom Friends'. That seems to be the only title amongst Garland's exhibited paintings that would fit this one, which it does very aptly. It is odd, if perhaps not unusual, that he exhibited it twice.

Private Collection

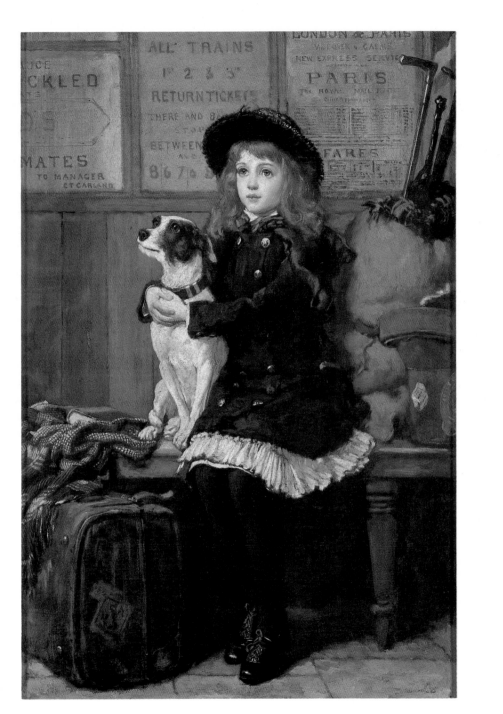

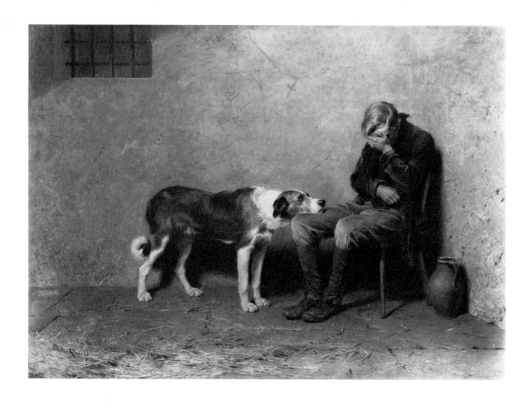

FIDELITY, 1869 *Briton Riviere, RA*

RISONERS' IS THE TITLE under which this painting was exhibited
at the Royal Academy in 1869. And indeed to modern eyes the
prison environment, with the gallows *graffiti* on the wall, is what
makes an immediate effect. But a public which had wept for
some thirty years over 'The Shepherd's Chief Mourner' was
going to have eyes only for the prisoner's faithful friend.

Briton Riviere's reputation has suffered unfairly because he succeeded Landseer
as the outstanding animal painter in the eighteen-seventies, and obviously he felt
it incumbent on him to produce a fair number of paintings emphasizing links
between human beings and their dumb friends. 'Without trying to render human
expression in a dog's face', *The Spectator* wrote, 'he nevertheless mastered the
points where canine and human nature touch, and painted them with an insight
and comprehension with which no other artist can compare.'

Lady Lever Art Gallery, Port Sunlight

[98]

THERE'S NO PLACE LIKE HOME, 1842 *Sir Edwin Landseer, RA*

 OT A DOG IN LONDON BUT KNOWS HIM', wrote *The Mask* in a contemporary comment on Landseer. There is no doubt of Landseer's genuine understanding of dog mentality, and the dogs' awareness of this. When asked by a lady how he had gained such knowledge of dogs and such power over them, he replied: 'By peeping into their hearts, Ma'am.'

What embarrasses many people, who are emotionally more inhibited than Victorian dog fanciers, is Landseer's quite unselfconscious tendency to assume that dogs talk in the canine equivalent of human language. The title of this painting might just as easily have been: 'Where have you been?' 'Why are you so late?' 'I thought you were never coming', or 'What's for supper?'

Victoria and Albert Museum

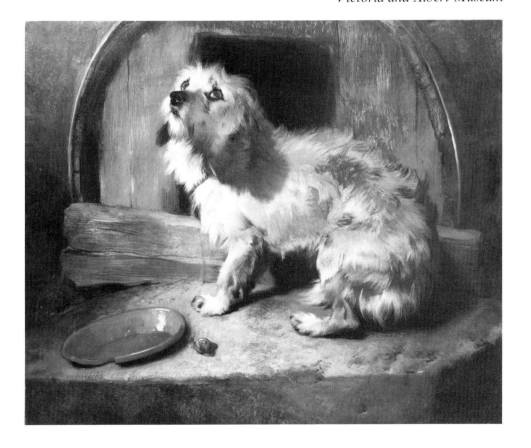

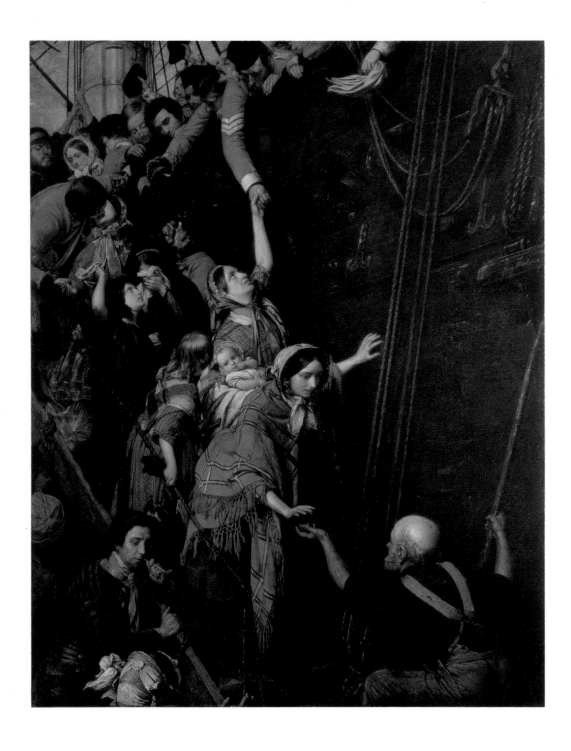

Soldiers of the Queen

ALTHOUGH BRITAIN was not involved in any Western European war during the reign of Queen Victoria the reign was violently interrupted in the 'fifties first by the disasters of the Crimean War and then by the massacres and reprisals of the Indian Mutiny. The Charge of the Light Brigade was commemorated in verse, but the only notable painting of the Crimean War, Lady Butler's 'The Roll Call', was not painted until twenty years after it happened. The Indian Mutiny was much better served by artists.

EASTWARD HO! AUGUST 1857, 1858 *Henry Nelson O'Neil*

 HE SUMMER AND AUTUMN OF 1857 saw the most bitter fighting of the Indian Mutiny, and by the time the Royal Academy opened in May 1858 the news of massacres and reprisals had stirred the public to respond with patriotic fervour to O'Neil's tableau of families saying goodbye to their menfolk as they embarked for India. *The Athenaeum* called the painting 'a triumph', and continued: 'The classes, the ages and the stations of the different leave-takers are admirably expressed and contrasted. The centre of all is a poor soldier's widowed mother, whose foot is just on the last step, and who is gazing with vacant, wet eyes, quite abstracted, on the rough boatman with the blue shirt and red braces, who is holding out to her his strong-knotted hand. Next up the steps comes a soldier's wife, a poor woman but decent enough in her red-chequered trailing shawl, neat straw bonnet and blue ribbons. She carries in her arms heedlessly (for her eyes are strained upward to catch a last look at the dear fellow's face) a child quite unconcerned, much amused by a soldier doll her elder sister is shaking before her eyes.'

A companion painting, 'Home Again', was painted by O'Neil. A reviewer for the *Art Journal*, who saw both paintings at the International Exhibition of 1860, wrote: 'This school of pictorial art is emphatically English . . . because Britain is a land of action and progress, wherein a contemporary art may grow and live, because in this actual present hour we act heroically, suffer manfully and do those deeds which in pictures and by poems deserve to be recorded.'

I do not recall reading art criticism written in such terms about the war of 1939–45.

Elton Hall Collection

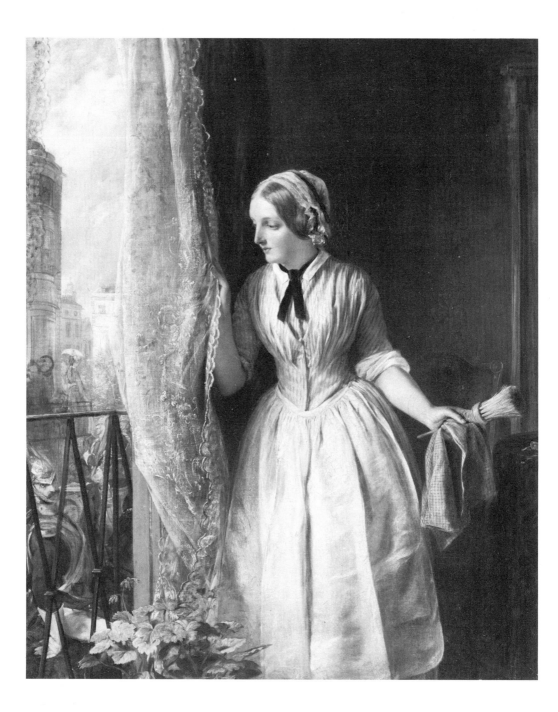

THE SOLDIER'S FAREWELL, 1853 *John Callcott Horsley, RA*

HIS DELIGHTFUL PAINTING is signed and dated 1853, and one is tempted to assume that the gallant trooper in the street is a member of the Light Brigade, on his way to the Crimea. That, however, postulates rather too keen a news sense in the artist, as Turkey did not declare war on Russia until October 4, 1853, and allied forces were not mustered in the Crimea until the spring of 1854. It is typical of Horsley, however, that the soldier has not even got a walking-on part in the picture. What Horsley was really interested in, as one can also observe in his 'Showing a Preference' (page 48), was a good-looking woman. In this case it appears to be a housemaid, and one therefore assumes – I hope rightly – that the soldier belonged to the 'other ranks'.

Whether or not one chuckles at the painter's obvious predeliction for what a contemporary categorized as 'sunshine and pretty women', one has to admire the skilful composition of this painting, the contrast between the darkness of the room with the lively gaiety of the street outside as disclosed by the drawing of a very elegant curtain. Everything in the picture is placed to maximum dramatic and – dare one suggest it? – romantic effect.

Sir Geoffrey Agnew

(*Overleaf*): THE SOLDIER'S RETURN *Thomas Faed, RA*

PPRECIABLY SMALLER THAN MOST of Faed's paintings (it is on millboard, $14\frac{1}{2} \times 19\frac{1}{4}$ inches) this provides an interesting social contrast to Horsley's much more romantic canvas. It is a little triumph of narrative painting, telling of the unexpected return of a wounded soldier to his humble Scottish home. His old father is listening to his mother, who is reading aloud the war news from the Crimea in the newspaper. An unmarried daughter is looking at another page of the newspaper, and her sister, the soldier's wife, sits sad-faced and disconsolate, her thoughts far away. Of her children, the eldest, a boy, is tying a hook to his fishing rod, which is only a stick of hazel as he cannot afford a proper rod. A younger son, on the left, has seen the door opening and his father slowly entering the room. One can almost hear him exclaiming: 'Feyther!'

This is a perfect little *genre* painting, as good as anything Faed painted.

Private Collection

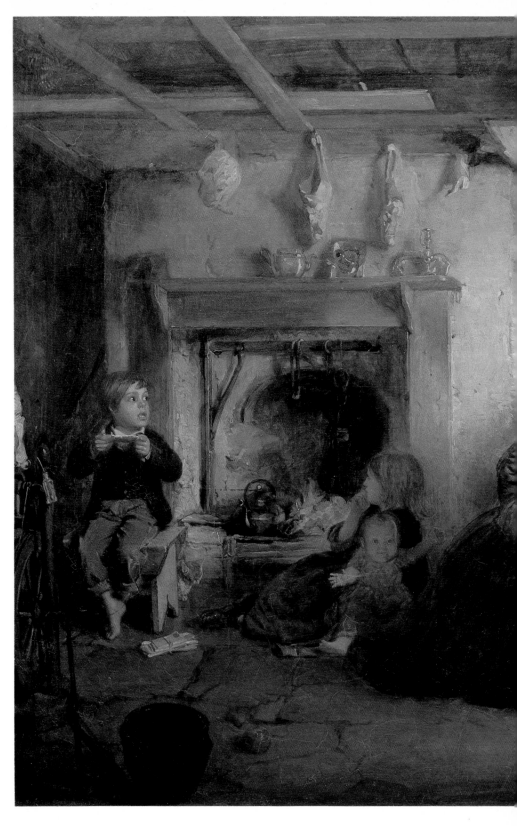

THE SOLDIER'S RETURN: *See preceding page*

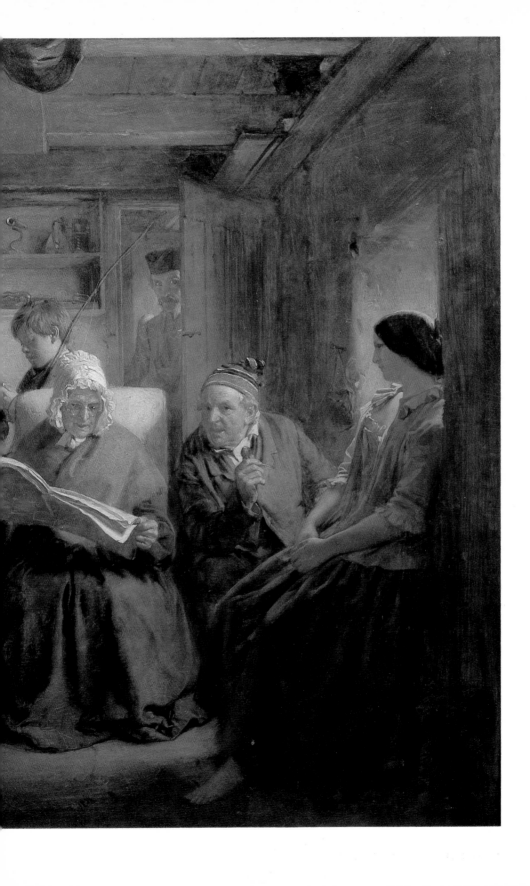

AN INCIDENT IN THE INDIAN MUTINY, 1857 *Edward W. J. Hopley*

URING THE SECOND WORLD WAR the Blitz and the tribulations of civilians on the Home Front provided many good artists such as Henry Moore and John Piper with subjects for outstanding works of art. There was no Home Front in the nineteenth century, and most British artists were able to continue painting peaceful scenes of undisturbed village life in an idyllic countryside. The Indian Mutiny, however, did provide vivid and terrifying scenes of civilians under threat and under fire. This painting of a British family roused at night, presumably in Lucknow (because the music on the stand at the right is 'The Campbells are Coming') is surprisingly by a painter known otherwise for allegorical and fairy subjects.

Photograph by courtesy of the Maas Gallery

[106]

VOLUNTEERS, *c.* 1860 *Arthur Boyd Houghton*

OLUNTEERS WERE THE VICTORIAN EQUIVALENT of the British Home Guard in the Second World War, though it did not take an actual war to bring them into being, only distrust of France as the dominant European power, and the Duke of Wellington's warnings of the weakness of the regular forces. From 1859 the War Office had grudgingly come to recognize the popularity of numerous 'rifle volunteer' corps and they were formed into battalions. For middle-class men, with a taste for uniforms, shooting and parades, the movement which in 1863 staged a parade of twenty thousand at Brighton became an innocent distraction for Volunteers and spectators alike. For Arthur Boyd Houghton the movement provided one of the crowd scenes he delighted to depict, with such humorous details as the little girl looking between a sergeant's legs and a lady so enthralled that she was running her pram into an elderly fellow-spectator.

Tate Gallery

THE EMPTY SLEEVE, 1856 *Thomas Roberts*

 OMETHING OF A PUZZLE is presented by this well painted, fairly small picture, which has hitherto been unrecorded and unillustrated. The subject is one that was a favourite with *genre* painters of the mid-fifties, a soldier returned from war having lost a hand in action, which is a matter of some curiosity to the child sitting on his knee. All the details of domestic life in a humble cottage are excellently depicted – the child's cot, the crouching cat, the birdcage, and the charmingly drawn young woman talking to a farm labourer at the door. The painting is rather light and thin, and the colours delightfully fresh and vivid.

It is, however, difficult to identify the painter, though the painting is fairly clearly signed and dated *Thos. Roberts 1856*. One's first inclination is to attribute the painting to Thomas Edward Roberts, RBA (1820–1901), who exhibited a number of *genre* paintings at the Royal Academy in the 1850s, but the treatment of this painting is very different from that of the painting attributed to Thomas Edward Roberts reproduced on page 128. Thomas Edward Roberts had a son, called Edwin Thomas, but as his birth is recorded as 1840 he is hardly likely to have been able to paint this picture in 1856. The date 1856 would account for the sitter's empty sleeve, his having lost his forearm in the Crimean War.

Private Collection: photograph by courtesy of the Guildhall Gallery,
Bury St Edmunds

The Lower Orders

CECIL FRANCES ALEXANDER, the hymn writer, in her mellifluous paean of praise for 'all things bright and beautiful', made it quite clear that this best of all possible worlds was based upon a firm social order:

> *God made them high and lowly,*
> *And ordered their estate.*

Such is the egalitarian outlook of the Western World today that sensitive church-goers are embarrassed as they sing those two lines, lest they are admitting to being 'upper-class' or 'stuck-up'.

Our great-grandfathers and great-grandmothers had no such inhibitions. In their time it was accepted that people belonged to the social order in which they were brought up, and there was no expectation that they would wish to change their circumstances. Occasionally people from inferior strata had enough talent or energy to 'get on in the world'; and in due course they acquired sufficient means or status to compete with 'their betters'; but they were regarded as *parvenus*; and the nauseous phrase 'He is not one of us' was used in all seriousness. These, however, were exceptional cases, leading as often as not to ridicule, such as was incurred, to the delight of the better-bred, by such inoffensive social climbers as Mr Pooter or Mr Jorrocks.

The members of the Lower Orders who accepted their lot were not necessarily regarded as inferior beings. There was not the bullying, persecution or ruthless discrimination against them that one finds, for instance, in such eighteenth-century novels as *Tom Jones*. As long as people 'knew their place' and accepted the existing order, they were generally treated with kindness and respect and a sort of paternalism that took a lot of responsibility for the well-being of servants, housekeepers, governesses, seamstresses, grooms and gardeners, farm workers and even clerks, foremen and other employees in family businesses.

Although I myself was brought up in a bourgeois environment in the early years of the twentieth century, it had existed for a hundred years or so, and had inherited many of the attitudes of what my family candidly regarded as 'the upper classes'. My mother, who abhorred snobbery, nevertheless instilled in me at an early age the obligation that the needs of 'servants and animals always come first' – before, that is, one's own comforts.

It was not an unhappy social set-up, for all its implicit snobbery and dis-criminatory conventions. And such phrases as 'the servants' or 'the lower orders' were commonly used without any sense of superiority or denigration.

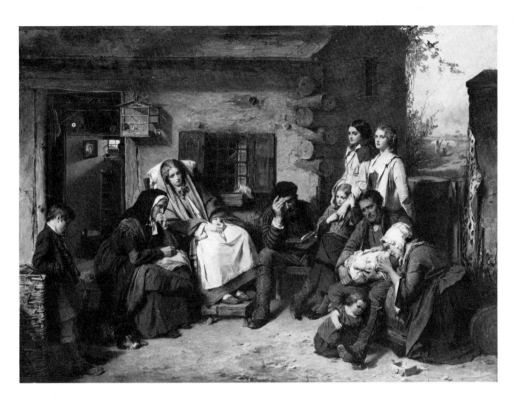

SUNDAY IN THE BACKWOODS, 1859 *Thomas Faed, RA*

 HROUGHOUT THE SECOND HALF of the nineteenth century, during which he exhibited nearly a hundred paintings at the Royal Academy, Thomas Faed was faithful to the Scottish peasant roots from which he sprang, and which are characteristically depicted in this painting. When he submitted his first Academy picture, in 1851, Faed was living in Edinburgh; but from then on he sent in his paintings from various addresses in London. The themes, however, always remained much the same, keeping alive the tradition of Scottish regional painting so notably established by Wilkie. Although the titles of his paintings, such as 'Cottage Piety', 'The Mitherless Bairn' (see page 35), 'Home and the Homeless', 'My Ain Fireside', and 'Worn Out', were attuned to Victorian sentimentality, the paintings themselves have a documentary value as realistic records of Scottish peasant life.

Wolverhampton Art Gallery

[111]

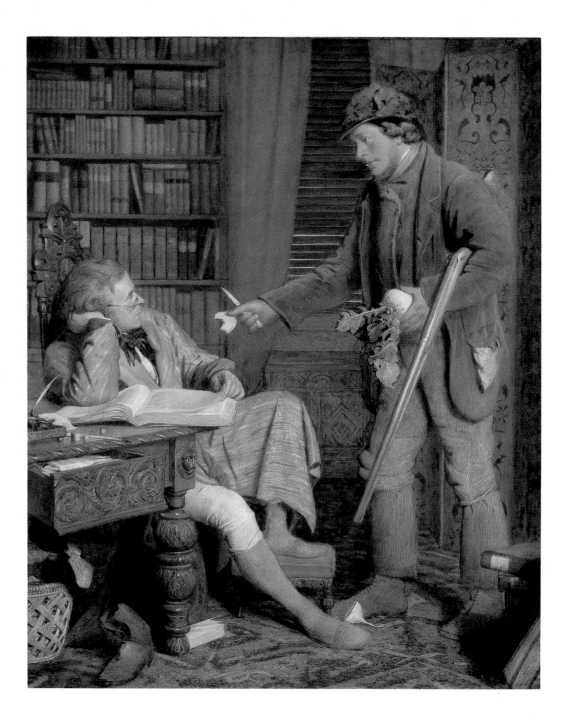

A DEMURRER, 1873 *James Lobley*

 CERTAIN AMOUNT OF DOUBT surrounds the title of this admirably painted narrative painting, and even about its attribution to Lobley. He was a Yorkshire painter of humble birth who exhibited fifteen pictures at the Royal Academy between 1865 and 1887 but attracted little public attention until an exhibition of his work was mounted by the Bradford Art Gallery in 1983.

The painting reproduced here was exhibited at Bradford with the title 'The Squire and the Gamekeeper', but this seems to have been merely a descriptive title, and does not correspond with that of any of Lobley's paintings exhibited in his lifetime. There is a good case for this picture having been the one exhibited at the Royal Academy in 1873 as 'A Demurrer', the Squire being a scholarly gentleman, perhaps an invalid with a bandaged leg, who 'demurs' from taking a practical interest in his estate or in the well-being of his farm-workers.

However that may be, there is plenty of scope for discussion about the theme of the painting and its exact significance. The so-called Squire is obviously sitting in his library – the blinds drawn on a fine day – and is more interested in the book he is reading than in the outpourings of his gamekeeper, whose wages appear to be waiting for him on the table.

The gamekeeper's apparently vehement comments seem to concern turnips, and it may be that he is complaining about having to live on turnips while the squire lives in luxury. He offers the squire a slice of turnip to taste. Dr Hardman, of Warwick University, suggests that Lobley had met Ruskin, who had written about 'literary persons whom the peasant pays in turnips for talking daintily to him'. Clearly there is a good deal of research still to be done on Lobley and his dialectical messages, but in the meantime we have a most unusual and intriguing social comment on the relations between country gentlemen and their employees.

Private Collection

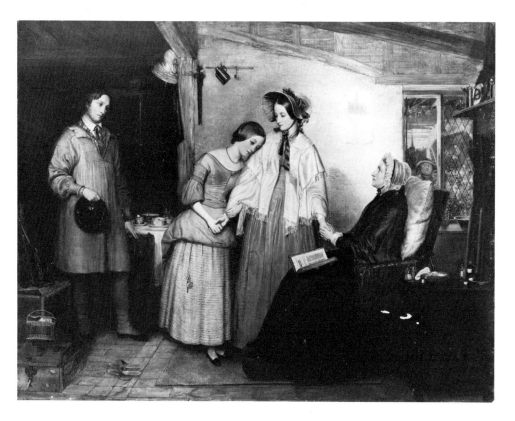

GOING TO SERVICE, 1843 *Richard Redgrave, RA*

EDGRAVE WAS A MOST INTERESTING and unusual character. He was a highly esteemed Academician, who devoted time and effort to his official duties, to schemes of education, to being Keeper of the Paintings at the Victoria and Albert Museum, and Inspector of the Queen's Pictures. In what little time was left to him for his own creative work he seemed to concentrate on bleak and unrewarding aspects of contemporary life, not in any polemical or political spirit, but simply in terms of conveying understanding for people who led sad and underprivileged lives. The painting reproduced here is a touching and very sympathetic study of a young woman, who seems to have had no better 'prospects' in life, leaving home for service in a lowly capacity in some richer person's home. I find it a moving statement, as well as a beautifully painted picture.

Private Collection

[114]

MAIDS OF ALL WORK,
1864–5 *John Finnie*

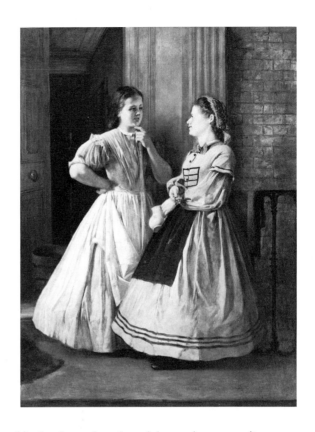

ERE WE SEE the kind of service the girl on the opposite page would probably be entering. Mrs Doris Langley Moore, the Founder of the Museum of Costume at Bath, has been kind enough to comment on the differences in dress between the two young women. 'The girl with the black apron,' she writes, 'may well be a housemaid or a seamstress. I think the latter, because a housemaid's apron would usually be white, and this girl appears to be carrying a pair of scissors and something that might be a piece of sewing – a cap?'

'The cap was obligatory for the lower ranks, and as the other young woman is not wearing one, and wears a more elaborate dress, she might be a housekeeper, or a lady's maid. But there is something that is not quite convincing about her outfit. The draped tablier is much in advance of the fashion in 1865, and the wearer may indeed be the mistress. Crinolines were worn by all ranks in the eighteen-sixties, though less elaborate for maids than for mistresses.'

London, The Geffrye Museum

[115]

OOR GIRL! She is overwhelmed by a wave of home-sickness such as we must all have experienced at some time in our youth. But, judging by the appearance of the room she is dusting, the house is a pleasant, not too large middle-class one – a few notches above the home of the Pooters, say – and if she has a kind and sympathetic mistress she will soon recover.

As regards her status, she is too inexperienced to be a 'general'; nor, for the same reason, could she be a house parlourmaid. It is probable that she is just a single-handed housemaid, with a cook below stairs who will, as likely as not, be inclined to push her about to show her superiority. For in those days the hierarchy and class-consciousness below stairs and behind the green baize door were just as pronounced as they were above stairs.

As Jeremy Maas says in his book on *Victorian Painters:* 'Alfred Elmore . . . born while the Battle of Waterloo was in progress, ran the whole gamut from historical painting to full-blooded modern *genre.* He was still exhibiting up to within a year of his death.' Judging from their tedious titles the many historical subjects he exhibited at the Royal Academy in the 'fifties could well have been dispensed with. But the small and unambitious painting opposite, together with 'On the Brink' (see page 130), suggest that modern *genre* was his *forte.* And the late J. B. Priestley owned a small but very strongly painted female nude (reproduced in colour in Priestley's *Particular Pleasures*, 1975) which indicates how lamentably Victorian artists were misled by the convention that they had to re-create large and impressive slabs of history in order to make their mark.

Private Collection

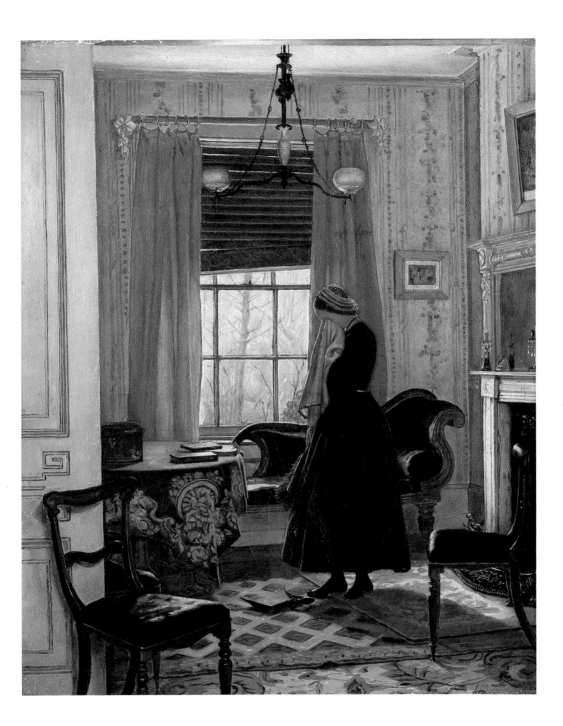

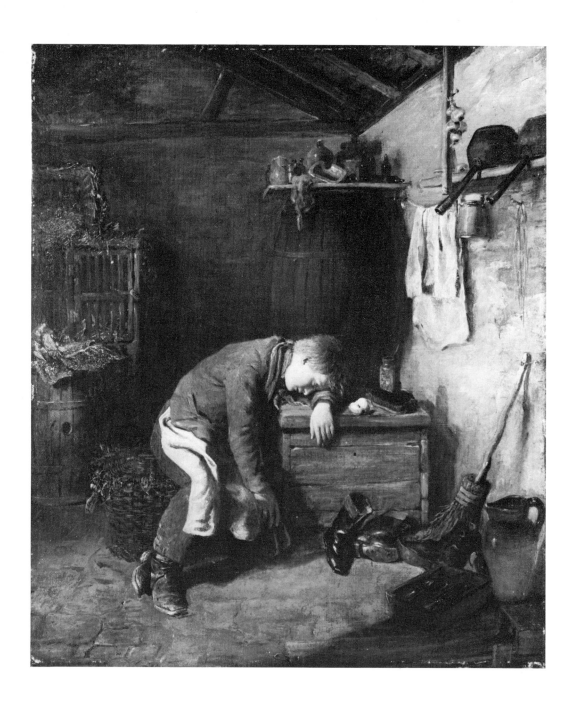

THE SLEEPING BOOTS BOY

George Smith

READERS OF *Pickwick* probably have an impression of a mid-Victorian 'boots' based on the perpetually cheerful Sam Weller, formerly boots at the White Hart in the Borough. They would find it difficult to reconcile their impression of that lively and facetious character with that of the weary boots boy depicted by George Smith, probably only a few years after Sam Weller entered the service of Mr Pickwick. Appropriately, this charming little painting is now the property of the Borough of Southwark, and is to be seen in the South London Art Gallery, in Peckham Road, only a couple of miles distant from the site of the old White Hart.

London Borough of Southwark, South London Art Gallery

THE POACHER'S DAUGHTER, 1884 *'Archie' Stuart-Wortley*

'OH, 'TIS MY DELIGHT on a shining night, in the season of the year. . . .' Preservation of game was one of the safeguards of the Victorian *status quo*. But anyone who ever listened to Benjamin Britten's and Peter Pears's rollicking rendering of 'The Lincolnshire Poacher' will realize that folklore elevated the lawbreaker into a Robin Hood.

This dramatic picture, by a sporting gentleman who had been taught to paint by Millais, shows an unsentimental view of the poacher. Surrounded by the spoils of the midnight foray, he seeks moral support from his loyal daughter, who is hastily cleaning the barrel of his shot-gun, since both of them have heard approaching footsteps. They are gazing fixedly into the fireplace, pretending they have heard nothing, whilst the faithful terrior cringes underneath a chair alongside a dead pheasant. The keen-eyed spectator, however, will observe through the narrow gap of the opening door the uniform of an Officer of the Law. *Usher Gallery, Lincoln*

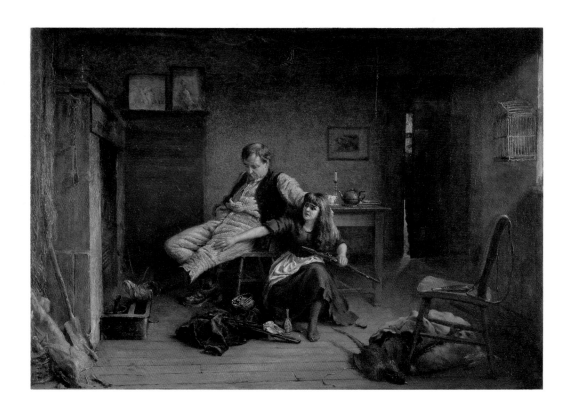

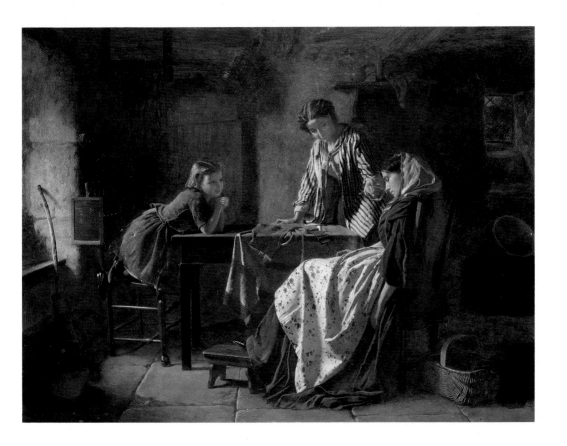

THE TIRED SEAMSTRESS, 1866 *William Henry Midwood*

 NE IS A LITTLE SURPRISED that this painting is not by Richard Red-grave, who made something of a corner in seamstresses. But this is signed by William Henry Midwood, a little-known painter of *genre*, who worked in London in the 'sixties and 'seventies. He exhibited 'The Amateur Musician' at the Society of Artists in 1867, and 'Yarn Spinning' in 1871. 'Card Castles', dated 1871, is illustrated in Christopher Wood's *Dictionary of Victorian Painters*. But although Mr Wood says his work appears quite often on the art market, very little is known about him except that he lived in Bolsover Street in London. Yet this is a decidedly competent anecdotal painting, the figures and the clothes and the flagstones well drawn, though the background is rather sketchily filled in. It only goes to show how many very capable *genre* painters were at work in the mid-Victorian period. © *Christie's Colour Library*

[121]

GOING TO THE FAIR, 1837 *Thomas Webster, RA*

 AINTED IN THE YEAR when Queen Victoria came to the throne, this is appropriately an expression of the traditional spirit of Merrie England which she inherited and which people have tried to recapture ever since. In fact it is one of a pair of pictures, painted one after the other. The second is called 'Returning from the Fair'. Pairs of pictures, illustrating two stages in the same story, were much favoured by narrative painters, and also presumably by their customers. Curiously, the first of the pair was often much livelier and convincing than the second; and that certainly applies to this pair. The successor is a much less entertaining image, and a much less effective composition.

The first painting, however, is a real delight, as beautifully composed as anything that Thomas Webster painted, and expressing a *joie de vivre* and gaiety that his later paintings often lacked. The child on the doorstep sets the tone for the whole picture – all expectation and eagerness, determined to make a day of it, with that grown-up hat on her head and the walking stick to give self-assurance. The swinging limbs of the boy, dragging his grandfather towards the door, are beautifully drawn, and the slightly older girl who is joining in the fun is 'as pretty as a picture' in the bonnet she is wearing for the occasion.

The gem of the painting, however, is the figure of – yes, we have to use the family soubriquet, 'Grandad', with an expression in his face of being slightly taken aback by the excitement and jollity around him, but, despite all, moving towards the open door almost in the steps of a dance.

Behind the group in motion come the more sober elements in the family. There is Grannie, her face wreathed in smiles, who is prudently counting the coins which her grandson is handing to her. And behind her is the father of the household, stern and responsible despite his relative youth, but wearing his best hat (a shade too large for him) and a rudimentary stock. Almost forgotten in the flurry of the departure is the children's mother, who is standing at the foot of the stairs, not quite sure whether she is expected to join the others, but wearing her best dress and a very stylish bonnet, so that she *will* be ready for the jaunt, if wanted.

It is almost impossible to imagine a *happier* painting of the activities of a humble yeoman family in what one doesn't hesitate to describe as 'the good old days'. Are any of us as happy today?

Victoria and Albert Museum

[122]

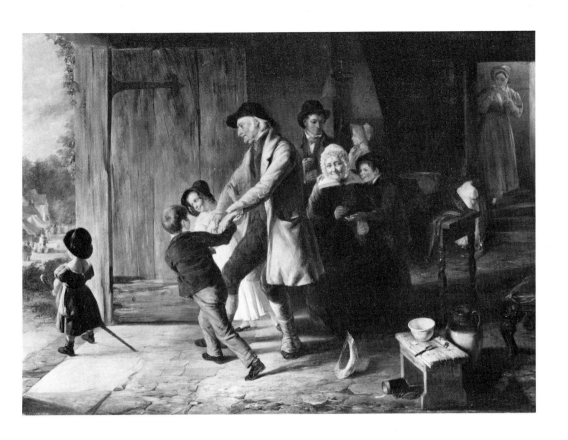

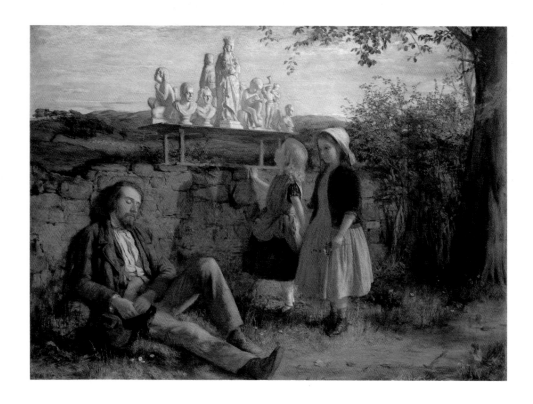

THE ITALIAN IMAGE SELLER, 1862 *Hugh Cameron*

ICTORIAN HIGHWAYS AND BYWAYS had a varied itinerant popu-
lation, consisting of tramps – usually euphemistically referred
to as 'travellers' – gypsies, hoping for a week or two of hop-
picking, knife-grinders with their raucous machines, and travel-
ling entertainers with model stages, Punch and Judy shows and
puppets. They were all commemorated by artists in search of
the picturesque. The painting above is not only one of the most visually striking,
because of the sharp contrast between the shining white figures and the familiar
soft rolling landscape, but also because of the unusual subject, an itinerant Italian
selling white busts and religious images. It was exhibited at the Royal Scottish
Academy in 1862.

Cameron was a Scottish painter who had studied in the Trustees Academy and
his work has been compared with that of Sir William McTaggart. *Maas Gallery*

THE VILLAGE COBBLER, 1885
Thomas Hill

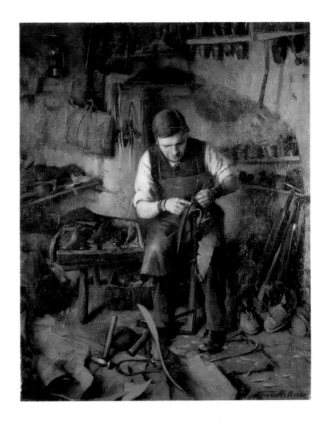

A T A TIME WHEN MOST PEOPLE in the countryside walked or rode on horseback to and from work boots were an essential part of their equipment. In consequence there were more cobblers in a country town or village than any other craftsmen. For instance, in the small Suffolk market town of Debenham, with a population of 1,667 in the year 1841, there were eleven cobblers, as against seven tailors, five grocers, five bakers and four blacksmiths. In *Over to Candleford* Flora Thompson, writing about her Uncle Tom, makes the point that people of all classes except the very poorest had their footwear made to measure. 'Uncle Tom's workshop was a back room of the house, with a door opening onto the yard. He made the hunting boots there and sewed the uppers of the more delicate makes, and there he fitted the customers, excepting the hunting ladies, who tried their boots on in the best parlour.' The cobbler, too, having a constant stream of customers to his door, was a regular source of local news and discussion.

Wolverhampton Art Gallery

[125]

GONE, *c.* 1877 *Frank Holl, RA*

T IS UNFORTUNATE, to my mind, that this masterly painter had so natural and effective a faculty for portraiture that he spent all the latter part of his life painting portraits of Eminent Victorians which earned for him the reputation, to quote an obituary notice, of being 'beyond all comparison the most popular of our living portrait painters'. Comparisons were readily made with the work of Millais and Watts – even with that of Rembrandt and Velazquez!

I am much more interested in his earlier work, which can broadly be called 'social realism', in which every picture does indeed tell a story, with the dramatic force of a painter in powerful command of his method and his materials. The best known of these paintings is probably 'No Tidings from the Sea' (1890) which is a much more dynamic presentation of the theme of Frank Bramley's well-known 'A Hopeless Dawn' (1888). It was commissioned by Queen Victoria. Even more dramatic is 'Newgate-Committed for Trial' (1878) which shows a wife with her children visiting her husband behind bars.

Not so well known is 'Gone', in which the message is punched home with not quite such explicit comment as it is in the other paintings mentioned, but is implied in the grouping and expressions of the family group who have just said good-bye to the departed son or husband on his way to emigration. The forcefulness of this painting is much enhanced by the boldness of drawing and the strong colours. This is decidedly *not* a typical Victorian painting, except insofar as it deals with a subject of burning interest to the Victorians – emigration.

London, The Geffrye Museum

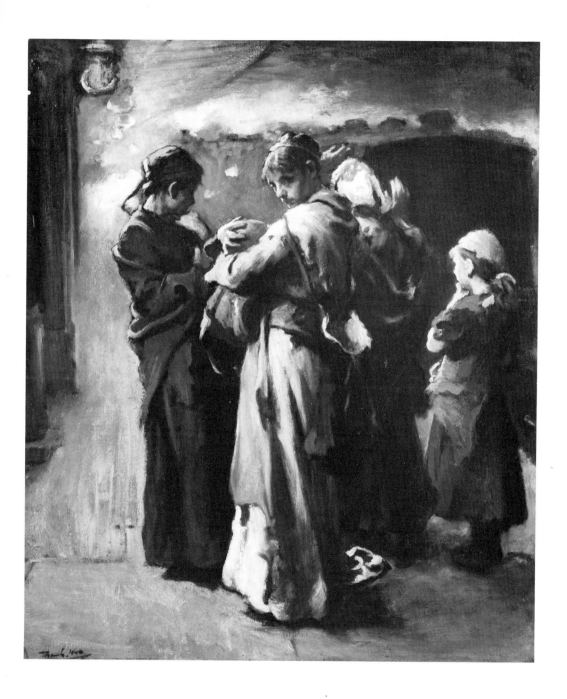

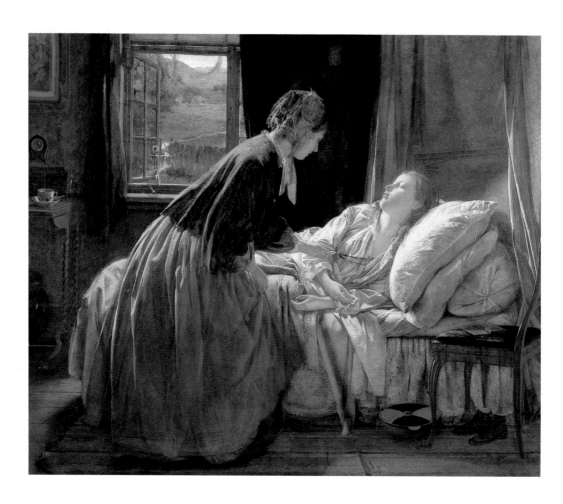

Frailty, Thy Name is Woman

THE DISCOVERY, 1851 *Thomas Edward Roberts*

SOME NICE PROBLEMS are posed by this beautifully painted picture. It is signed simply *E. Roberts, 1851*, but it has been attributed to Thomas Edward Roberts. The 'discoverer' is the lady, wearing a wedding ring, who is bending over the bed and examining the sleeping girl's locket. What is in the locket? Is it a lock of hair, which Victorian women often carried in a locket? If so, whose hair? Could it possibly be a lock of the discoverer's husband's hair? Or could the locket contain a tiny miniature painting of her husband? Clearly the contents are something of distressing significance, which was the reason for the painting of the picture and for its title.

But who is the sleeping girl? Is it a younger sister of the married woman, who had never suspected her of any entanglement. 'And I did think my sister was pure!' That would be a shattering discovery.

Equally likely is that the girl is not her sister, but a servant, who is ill, and into whose room her mistress has come to see how she is getting on. Admittedly she has a book by her bedside, but it may be just a trashy romance; unfortunately one cannot see the title. And the room looks rather like a servant's bedroom, with its cheap worn carpet, the pot of flowers on the window sill, and the teacup left untidily on the dressing table.

The girl could, of course, be just a friend, staying in the house; but it would be very unlikely for the hostess to walk in, and start examining the locket whilst the visitor was still asleep. No, the balance of probabilities is that she is a servant. 'What a fool I was to engage that good-looking girl; but I never suspected that Harry would make a fool of himself over her.'

Is there some significance in the two butterflies that are hovering over the same flower? Two women in love with the same man? Did the artist add them to keep us wondering, or just to add another touch of decoration to what is a very decorative and attractive painting.

Private Collection

[129]

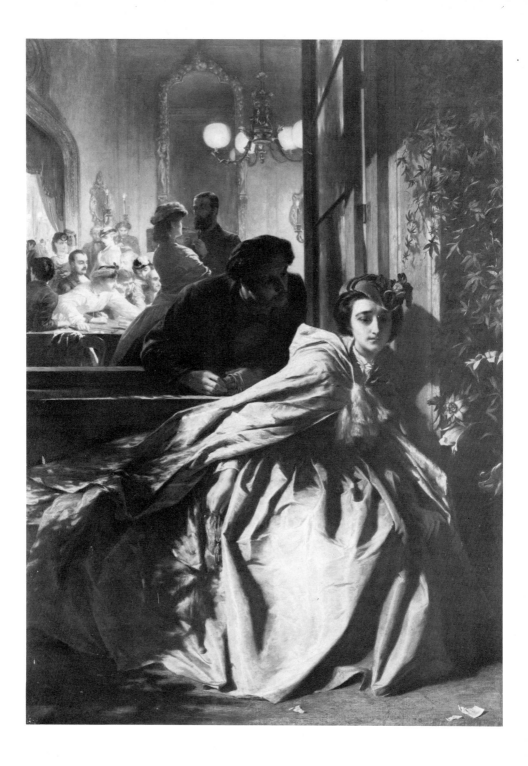

ON THE BRINK, 1865

Alfred Elmore, RA

HEN THIS PAINTING was exhibited at the Royal Academy in 1865 *The Art Journal* described it in terms which, no doubt, perfectly expressed the reaction of the average viewer at that time: ' "On the Brink" is a misadventure wrought by the gambling table of Homburg. The title, which is intentionally vague, suggests a sequence. A lady who in high play has sustained fatal loss rushes with empty purse from the scene of disaster and is here seen on the brink of certain ruin and possible suicide. In the den within, a gay company of gamesters is still engaged in reckless rivalry. Such is the contrast between hope and despair.'

This description is all very well as far as it goes, and it quite correctly emphasizes the dramatic contrast between the lady's distress and the fashionable gaiety of the social scene in the background. But it does nothing to explain the presence – the somewhat sinister and enigmatic presence – of the gentleman leaning out of the window, who is clearly a protagonist in the drama that is being enacted. Is he the lady's husband pleading with her to pull herself back from 'the brink'? I do not believe that any English gentleman would accompany his wife into such disreputable company. A mistress, perhaps? There is more than a hint of the irresponsible neer-do-well in the man's expression and the hands that seem to be moving towards an amorous embrace. I can imagine the upright bearded gentleman saying to the elegant lady in the background: 'You see that young feller over there? Wouldn't trust him a yard.'

Nor would I. And that makes me think that although the setting may be a casino, with roulette obviously in progress at the table, the lady's predicament is just as likely to pose a sexual as a financial problem.

I wish I could read the writing on the torn-up note at the lady's feet. Or is it a banknote?

In the mid-nineteenth century Bad Homburg had a bad reputation, not only for gambling but for other breaches of respectable behaviour. Was is not here that in one of his paintings Frith shattered the rules of polite deportment by allowing a young woman to light a cigarette – out-of-doors, and in public!

The Fitzwilliam Museum, Cambridge

[131]

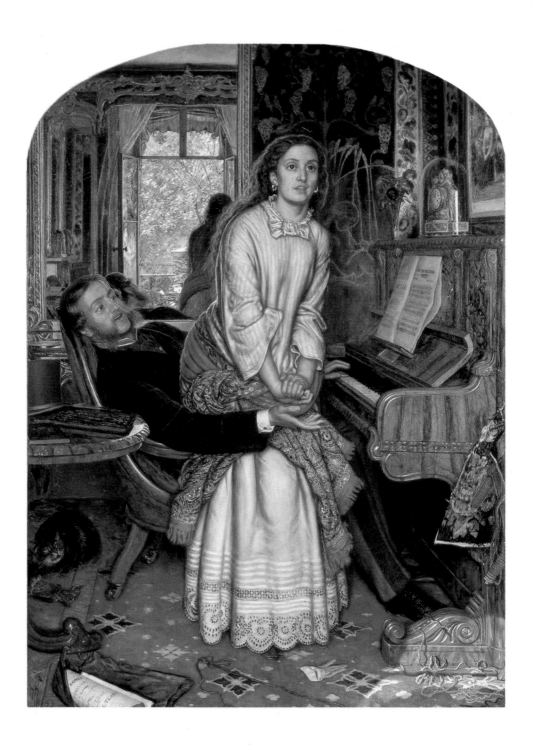

THE AWAKENING CONSCIENCE, 1853 *William Holman Hunt, OM*

N THIS INSTANCE there is little doubt that it is the 'old, old story'. The artist was at some pains to explain to friends that 'The Awakening Conscience' was a materialistic counterpart to his religious 'Light of the World'. In fact it is a completely independent study of a situation that was familiar to the world at large in mid-Victorian days – the 'fallen woman' who begins to repent of her descent down the slippery slope. Holman Hunt was determined to invest his picture with tearful symbolism. He asked for the frame to be inscribed with a quotation from *Proverbs*: 'As he that taketh away a garment in cold weather, so is he that singeth songs to an heavy heart.' He wanted to show how 'the still small voice speaks to a human soul in the turmoil of life'. The music title, 'Tears, idle Tears' is rolled up on the floor.

The room which the artist chose as a setting for this 'cautionary tale' was in Woodbine Villa, 7 Alpha Place, St John's Wood – an area renowned for its *maisons de convenance*. The gentleman's features, dress and gestures are self-explanatory, and almost every detail in the room drips with sexual and moral innuendo. The girl's lack of a wedding ring is obvious, as is also 'her provocative state of undress'. The lover's discarded gloves, lying on the floor, symbolize a cast-off mistress, and the web in which the victim is trapped is symbolized by the tangle of embroidery threads on the carpet, the convolvulus in the vase on the piano, and the crafty cat crouching under the man's chair.

The seducer, inadvertently, is introducing the note of repentence by singing (from the music on the piano):

> *Oft in the stilly night*
> *When slumber's chain has bound me,*
> *Fond memory brings the light*
> *Of other days around me.*

The girl's open lips and dilated eyes reveal 'the awakening conscience', which is symbolized by the French clock bearing a design in which Cupid is bound by chastity, and by the mirror, which reflects an idyllic scene outside the window.

More than any other painting of its period does this express the Mid-Victorian fascination with, and revulsion from, sexual irregularity. It might also be regarded as a characteristic expression of Victorian hypocrisy, since the model who posed with such a touching air of repentance lived with the artist as his mistress for several years. It is no surprise to learn that Holman Hunt was awarded the Order of Merit and was buried in St Paul's Cathedral.

Tate Gallery

[133]

THOUGHTS OF THE PAST, 1858–9 *John Roddam Spencer Stanhope*

OW WE ARE DREDGING the depths of the Pre-Raphaelite pre-occupation with fallen women. In a sordid bedroom overlooking the River Thames at Blackfriars a woman of the streets interrupts her toilette to contemplate her sorry condition. The background of the room exemplifies her plight: cracked window panes, a torn curtain, pot plants struggling towards the light, rejected posies of violets and primroses, the slovenly half-opened drawer of the dressing table, a man's walking stick and glove on the floor, and – is that perhaps *his* money on the table?

No wonder that she tugs aimlessly at her dyed hair, cannot be bothered to dress, and views life through jaundiced eyes. The cleverly painted bustle of the river scene through the window emphasizes the contrast between normal, active, industrious life and the dead-end depression in her demeanour.

It is sad that the Pre-Raphaelites could not make sin a little more enjoyable. After all, why did men and women indulge in it unless they got some pleasure out of it? There is no pleasure in this picture, which was painted in a studio which Stanhope occupied, below Rossetti's, in Chatham Place, Blackfriars. In June 1858 a friend called on Rossetti and then went into Stanhope's studio to look at a painting of an 'unfortunate' which Stanhope proposed to paint at two different crises in her life. The other 'crisis' does not seem to have materialized – at any rate on canvas. It was assumed to have been concerned with the girl's seduction. Fanny Cornforth was recorded as the model. About this time she sat to Rossetti for the head of the fallen woman in his well-known painting, 'Found'; but the features do not correspond. One can only hope that in the other canvas of the diptych she would have looked as though she were enjoying her frolic.

Tate Gallery

[134]

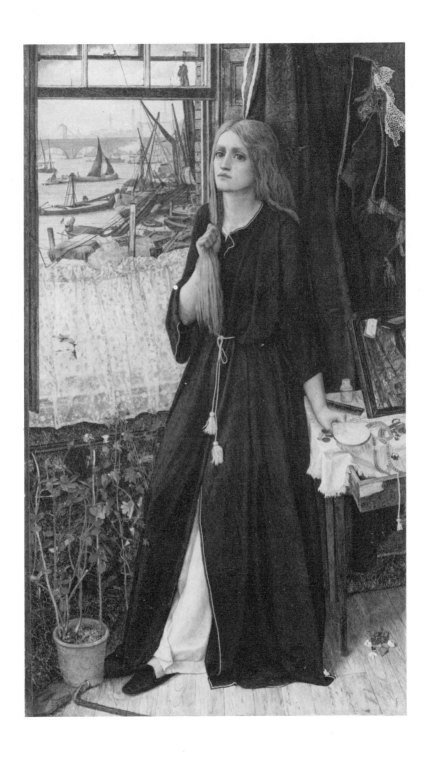

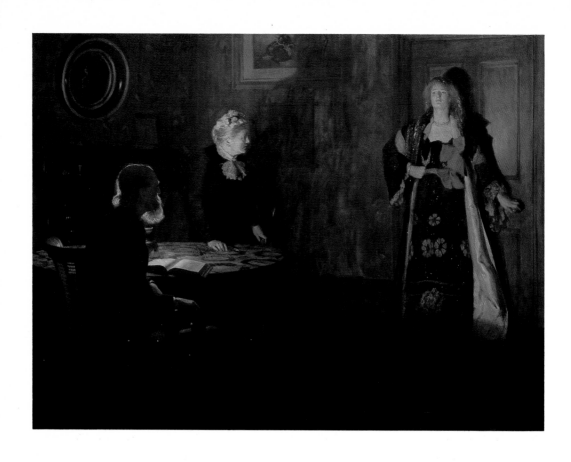

THE PRODIGAL DAUGHTER, 1903

The Hon. John Collier, RA

OT STRICTLY A VICTORIAN PAINTING, as it was not exhibited until 1903, this picture was probably in the painter's mind before the Queen died, and it so completely epitomizes the Victorian outlook on domestic morality as to demand inclusion in a book on the theme of Victorian story painting.

About the turn of the century Collier was the greatest popular exponent of the so-called 'problem picture'. He always maintained that his were not problem pictures, and in his obituary *The Times* quoted him as saying that his so-called problem pictures 'merely depict little tragedies of modern life, and I have always endeavoured to make their meaning perfectly plain'. Indeed he had. His titles included 'Trouble' (1898) 'The Cheat' (1905), 'Mariage de Convenance' (1907) and 'Sentence of Death' (1908).

When 'The Prodigal Daughter' was exhibited the *Art Journal* shrewdly commented on its appeal: 'The setting of his scene is plainly suburban and middle-class, a commonplace, shabby-genteel room in which the prodigal daughter, dressed in showy finery, seems strangely out-of-place. Mr Collier has not, however, depended simply upon the assertion of everyday facts to give interest to his work and he has made the subject an excuse for painting an admirable effect of artificial light and for securing clever differentiation in types of human character. The picture is a curious commentary on heredity: it seems almost impossible that such a type of woman as the daughter who has gone defiantly her own way could have sprung from surroundings so conventional and narrowly respectable. The artist, indeed, suggests a problem which offers scope for wide discussion.'

The Times jumped to the challenge: 'This is the English Magda – the runaway daughter of a quiet old couple, returning in her finery to her simple home. The details of the dramatic moment are a little difficult to understand: has she just entered the room, or is she leaving it, repelled? Is she telling a story, or has she told it, unforgiven, and is she about to pass out into the night? These things want explaining, for a narrative picture ought to have no ambiguity; but meanwhile we can unreservedly admire the fine, upright figure of the girl, the tragedy of her face, the painting of her dress, and the old father's head seen against the lamp.'

Though I began by saying that this painting depicted a typically Victorian situation, I wonder if a somewhat similar picture could not be painted today, transposing if necessary the social *milieux* involved.

Lincoln, Usher Museum and Art Gallery

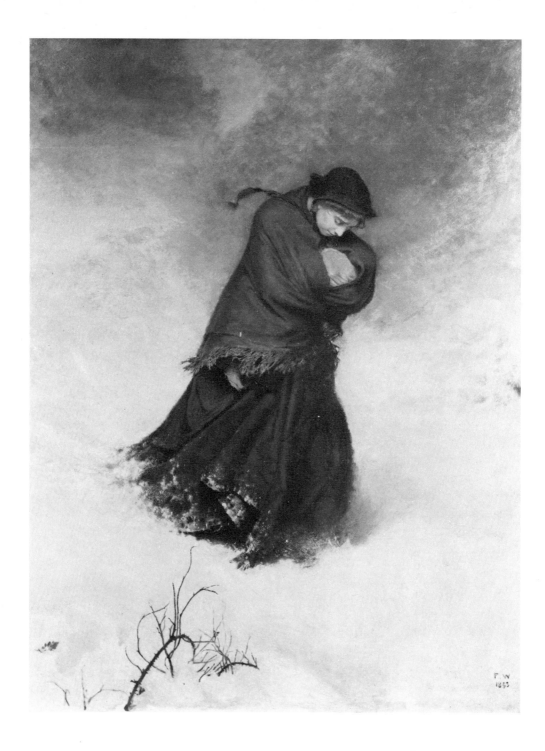

THE LOST PATH, 1863　　　　　　　　　　　　*Frederick Walker, ARA*

S AN EXIT PERFORMANCE it has all the classic elements – the snow, the stumbling footsteps, the downcast gaze, the tattered shawl, the 'bundle'. What is remarkable about it is that it was the first painting exhibited by Walker, who hitherto had been known only as an illustrator. It was not until 1858 that he began to paint in oils, and in that year he wrote: 'I may fairly say it diddles me completely.' He was much more at home drawing illustrations for *Good Words* and adapting sketches by Thackeray for the *Cornhill Magazine*.

In February 1863 he began to adapt in oils an illustration he had drawn for a poem called 'Love in Death' in the March 1862 issue of *Good Words*. He referred to it as 'my snow picture', and one does not know at what stage it acquired its emotive, symbolic title of 'The Lost Path'. At the Royal Academy in 1863 it attracted considerable attention though it was hung much too high in 'an undistinguished corner in the North Room'. It was returned to the artist unsold.

Walker had gone to a great deal of trouble over his first submission. His youngest sister, Mary, stood to him for the figure. As no real snow was available in March he used salt as a substitute for the snowflakes on her dress.

Seven years after its exhibition it was engraved for *The Graphic*, and five years later the figure of the woman was reflected by Luke Fildes in his famous painting of 'Applicants for Admission to a Casual Ward'. Partly because of its stark simplicity 'The Lost Path' makes a striking composition, and its theme epitomizes the Victorian fascination with the lot of 'unfortunate women'.

How, and why, this unfortunate woman found herself wandering in the snow is not explained in the poem for which it was originally an illustration. 'Love and Death' is a long, descriptive poem by Dora Greenwell, the American poetess, concerning a young woman who was seen wandering in the 'green mountains' of Vermont with a child in her arms. She prayed for rescue:

> *And in that prayer her fervent spirit pass'd,*
> *The deep night fell, the keen and hurrying blast*
> *Sang her wild dirge, the straining clasp grew cold,*
> *Yet press'd the little one with rigid hold*
> *Still to her heart: when morning came the child*
> *Woke peaceful in its mother's arms and smil'd.*

The poem appears to have been based on an actual reported occurrence. The mother was dead; the child lived.

Private Collection

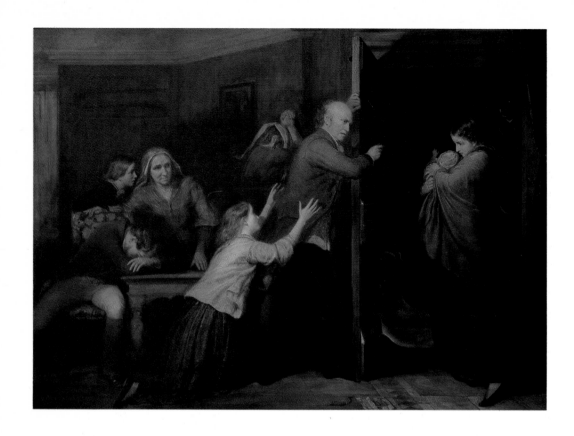

S I HAVE ALREADY SUGGESTED, Richard Redgrave was obviously concerned with the plight of women in 'distressed' circumstances. In the 1840 Academy he exhibited 'The Reduced Gentleman's Daughter' – a double-edged title if ever there was one. This was followed in 1843 with 'Going to Service' (see page 114), a foretaste of female frustration to come, and 'The Poor Teacher', which enlisted sympathy for the noble army of governesses. In 1846 he turned to the slavery of 'The Seamstress' and in 1847 to 'Fashion's Slaves'. There was no Women's Liberation Movement in those days.

It is difficult, over a hundred years later, to decide whether Redgrave was obsessed with the hardships of distressed womenfolk, or whether, as a prominent and successful Academician, he was 'catering for a market'. My own deduction is that both interpretations are true. The subject matter appealed to the mid-Victorians' sense of guilt over the way in which many underprivileged women had to live – and the ever-recurrent warning of the adage that 'there but for the grace of God go I'. But I am not inclined to doubt Redgrave's sincerity in his portrayal of the downtrodden. I am sure he was at one with the sympathies of his audience, even if at times they inclined to the maudlin.

I am not quite so sure, however, about the motivation of the painting reproduced on the opposite page, which was Redgrave's Diploma submission for the Academy in 1851. The banishing of an errant daughter had already proved a popular theme in Victorian art, on canvas as on stage; and Redgrave's Academy entry in 1838, 'Ellen Orford', derived from a poem by Crabbe, had shown a woman in disgrace with her bastard offspring. 'The Outcast' pulls out all the stops: the daughter's transgression, her stern father's insistence on punishment, the eviction into the snowy night, all supported by the print on the wall showing Abraham casting out Hagar and Ishmael. This is what happens to those who do not listen to Holman Hunt's 'Awakening Conscience'. As Augustus Egg will be telling us a few years later (and in the next two pages), the Embankment beckons.

Diploma Gallery, The Royal Academy

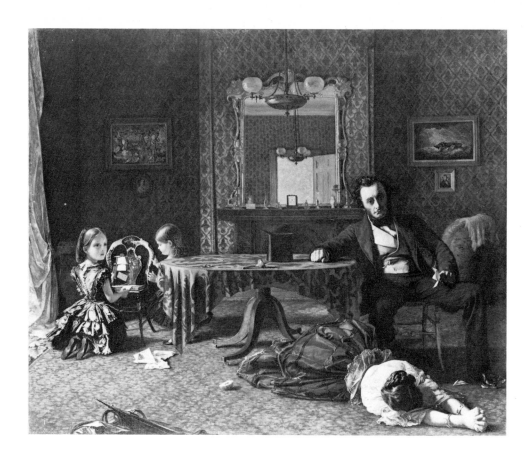

PAST AND PRESENT, I and III *Augustus Leopold Egg, RA*

HE THREE PAINTINGS in this harrowing series epitomize one of
the deep-seated apprehensions of Victorian family life. When
exhibited at the Royal Academy in 1858 they bore no title, but
the following note accompanied them: *August the 4th. Have
just heard that B——— has been dead more than a fortnight, so his
poor children have now lost both parents. I hear she was seen on
Friday last near the Strand, evidently without a place to lay her head.*

The first painting illustrates (literally) the first stage in her fall. Her husband
clutches the guilty letter he has found, and his foot crushes a miniature of his
wife's lover. As in Holman Hunt's 'Awakening Conscience' the whole scene is
packed with symbols: the sliced apple on the floor, the children's house of cards

[142]

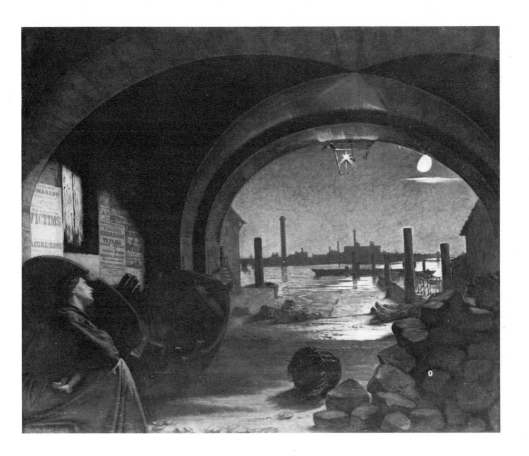

collapsing, the pictures on the wall of a shipwreck and of the expulsion from the Garden of Eden.

In the second picture of the series (not illustrated here) one of the children buries her head in her mother's lap as she says her prayers in the bedroom, whilst the mother gazes in despair out of the window at a waning moon. In the third and final painting the errant wife is again gazing at the moon, in its same quarter, but this time from 'underneath the arches' below the Adelphi in the Strand, where the down-and-outs traditionally foregathered. In her arms, under her drab shawl, is another baby child. Whose? The placard on the wall, advertising 'Pleasure Excursions to Paris', and a poster for the double bill at the Theatre Royal, Haymarket, including Tom Taylor's *Victims* and *A Cure for Love*, provide all the symbolism that is needed.

Tate Gallery

[143]

The Last of England

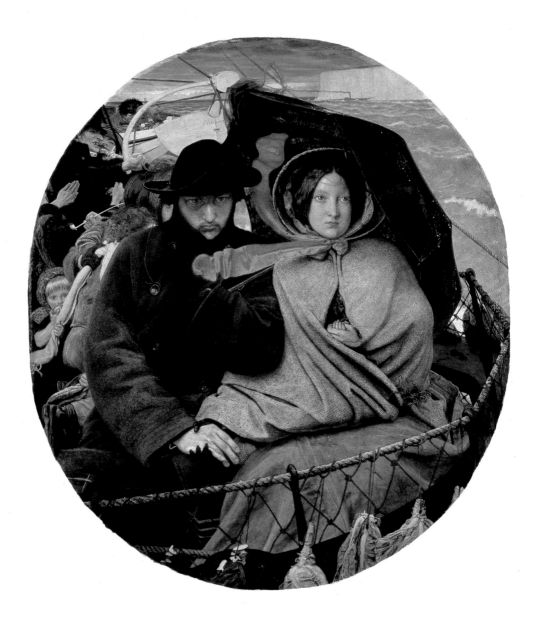

THE LAST OF ENGLAND, 1852–5 *Ford Madox Brown*

N A BOOK IN WHICH many of the paintings illustrated are not in the top aesthetic flight – whatever else their merits and interest – I suggest we should end with a painting of outstanding 'story interest' which is also an unquestioned masterpiece. Originally designed by Ford Madox Brown while living in lodgings in Hampstead, 'most of the time intensely miserable, very hard up, and a little mad', the painting reflects the emigration movement which reached its height in 1852. But it reflects it not from the usual point-of-view of the poverty-stricken working class, but as it appeared – to quote the artist's words – 'to a couple from the middle classes, high enough, through education and refinement, to appreciate all they are now giving up, and yet depressed enough in means to have to put up with the discomforts and humiliations incident to a vessel "all one class"'.

The artist continued: 'The husband broods bitterly over blighted hopes and severance from all he has striven for. . . . He is shielding his wife from the sea spray with an umbrella. Next to them, in the background, an honest family of the greengrocer kind . . . makes the best of things with tobacco-pipe and apples, etc. Still further back a reprobate shakes his fist with curses at the land of his birth . . . while a boon companion, with flushed countenance, and got up in nautical togs for the voyage, signifies drunken appreciation.'

The idea for the painting was prompted by the departure of Thomas Woolner, the sculptor, as an emigrant to Australia in July 1852, though there is no evidence that Madox Brown saw him go, as Rossetti and Holman Hunt did. Madox Brown's thoughts of emigrating to India were finally dispelled by the sale of this picture, as soon as it was completed, to his dealer D. T. White for £150, including copyright. For this Madox Brown altered the green of the seat, and added a rope and some rust and a string to the man's hat. It was a good bargain for Mr White.

City of Birmingham Museum and Art Gallery

[145]

Biographical Notes

ANDERSON, SOPHIE (1823–1903), was born in Paris, her father being a Frenchman. She studied under Steuben, but on the outbreak of the 1848 revolution her family went to the United States. She has some success as a portrait painter, and married an English artist, Walter Anderson. In 1854 they came to England and lived in Surrey and Falmouth. In 1855 she had begun to exhibit *genre* paintings at the Royal Academy. She continued to exhibit until 1896, mostly paintings with somewhat sentimental titles.

BROWN, FORD MADOX (1821–93), son of a ship's purser, was brought up and studied in Belgium. He moved to London in 1844, having married a cousin, who died in Rome in 1846. He gave lessons to Rossetti, with whom he became close friends. He won prizes at the Liverpool Academy in 1856 and 1858, when he was living in penury in Hampstead. In 1853 he had married Emma Hill, who became his model for 'The Last of England'. He was never actually a member of the Pre-Raphaelites, though closely influenced by them. He joined William Morris as a designer, and designed murals for the Town Hall in Manchester, where he lived from 1881 to 1887.

CAMERON, HUGH, RSA, RSW (1835–1918), was a Scottish painter of portraits and *genre* who lived in London from 1876 to 1888. Later he visited the south of France and painted in Italy. He exhibited at the R.A. in 1871 and 1872.

CARPENTER, MARGARET SARAH (1793–1872), was born in Salisbury. Her maiden name was Margaret Geddes. She came to London in 1814 and three years later married William Carpenter, Keeper of Prints and Drawings in the British Museum. She became well-known as a portrait painter and three of her portraits are in the National Portrait Gallery. She also painted several 'leaving portraits' for Eton College. She exhibited a number of portraits, mostly of women and children, at the R.A. and the Society of British Artists between 1831 and 1859.

CHAPMAN, R. W. (fl. 1855–61), was a painter of *genre* and historical subjects about whom little is known. He exhibited at the R.A. in 1855 and 1856.

CHARLES, JAMES (1851–1906), painter of landscape and rustic *genre*, studied at the R.A. Schools from 1872 and at the Académie Julien in Paris. He exhibited

at the R. A. between 1875 and 1906, and was one of the first to practise *plein-air* painting in England.

COLLIER, THE HON. JOHN (1850–1934), son of a Judge, subsequently Lord Monkswell, was educated at Heidelberg, studied under Poynter at the Slade School, and exhibited a number of much-discussed 'problem pictures' at the R.A., starting with 'A Glass of Wine with Cesar Borgia' in 1893. He wrote three books on the technique of painting between 1882 and 1905.

EGG, AUGUSTUS LEOPOLD, RA (1816–63), son of a well-to-do gunsmith, studied at the R.A. Schools and became a member of a clique including Frith, Dadd and H. N. O'Neil. He painted a number of literary and historical subjects, and was loosely linked with the Pre-Raphaelites.

ELMORE, ALFRED W., RA (1815–81), an Irishman, came to London aged twelve and entered the R.A. Schools in 1832. He lived in Paris, Munich and Rome until 1842. He exhibited regularly at the R.A. from 1832 to 1880, mostly historical or Shakespearean subjects. He was also an accomplished watercolourist.

FAED, THOMAS (1826–1900), younger brother of John Faed, was brought up at Burley Mill, Kirkcudbrightshire, and studied with his brother in Edinburgh. He moved to London in 1852 and made his name with 'The Mitherless Bairn' in 1855. He was elected A.R.A. in 1859 and R.A. in 1864. Between 1851 and 1893 he exhibited nearly a hundred paintings at the Academy, most of them depicting the life of Scottish peasants. Much of his income was derived from the sale of engravings of his paintings.

FARMER, Mrs ALEXANDER (fl. 1855–67). There is some doubt as to whether she or her husband painted the pictures attributed to her (see page 27). They lived at Porchester in Hampshire.

FILDES, SIR SAMUEL LUKE, RA (1843–1927), began his artistic career as an illustrator of magazines and of Dickens's *Edwin Drood*. In 1874 his large and dramatic painting of 'Applicants for Admission to a Casual Ward' aroused great public interest; as did 'The Widower' (1876) and 'The Doctor' (1891). Later he became a portrait painter and obtained several Royal commissions for State portraits. He was knighted in 1906.

[148]

BIOGRAPHICAL NOTES

FINNIE, JOHN (1829–1907), was the dominant figure in Liverpool art at the end of the nineteenth century. He had begun as a house painter, but studied under William Bell Scott at Newcastle. In 1855 he became head of the Art School of the Mechanics Institution which became the Liverpool Institute. He exhibited forty-eight paintings at the Royal Society of British Artists between 1863 and 1887, mostly landscapes influenced by Millais and Corot, with a few *genre* subjects. He exhibited at the R.A. between 1861 and 1902.

FRITH, WILLIAM POWELL, RA (1819–1909), born in Yorkshire, studied at the R.A. Schools, began by painting historical and literary subjects, and then, with panoramic group paintings such as 'Ramsgate Sands' (1854), 'Derby Day' (1858) and 'The Railway Station' (1862), became famous as the outstanding narrative painter of his day. He also painted moralistic series such as 'The Road to Ruin' (1878) and 'The Race for Wealth' (1880). He exhibited at the R.A. from 1840 to 1902.

GALE, WILLIAM (1823–1909), a painter of historical and mythological subjects, studied at the R.A. Schools, and travelled much in the Near East. Exhibited at the R.A. 1844–93.

GARLAND, CHARLES TREVOR (fl. 1874–1901), was a Londoner who specialized in painting children and dogs. He exhibited between 1874 and 1901 at the R.A. paintings whose titles all suggest a strong animal element, as do 'Bosom Friends' (1881) and 'Beware of the Dog' (1882–3), which he showed at the Royal Society of Artists. He moved to Cornwall in his later years.

HARDY, FREDERICK DANIEL (1826–1911), after studying music for a time, moved to Cranbrook in Kent in 1854 where he shared a studio with Thomas Webster, and became a prominent member of the Cranbrook Colony. Others in the group were J. C. Horsley, A. E. Mulready and G. B. O'Neill. Also in the district were Helen Allingham, Birket Foster, Charles Keene, the architect Norman Shaw, and Sir Henry Cole, the founder of the Victoria and Albert Museum. F. D. Hardy was perhaps the most gifted of the Cranbrook painters, but his choice of subjects was very much the same as that of Webster and O'Neill – domestic scenes, with farmhouse and rural settings, and always several children. His brother, George Hardy (1822–1909), also painted domestic scenes with children, and exhibited at the R.A., 1846–92.

BIOGRAPHICAL NOTES

HICKS, GEORGE ELGAR, RBA (1824–1914), studied to be a doctor and went to the R.A. Schools in 1844. Painted several large group subjects, including 'Dividend Day at the Bank' (1859), 'The Post Office' (1860) and 'Billingsgate' (1861).

HILL, THOMAS (1852–1926) painted portraits, landscape and *genre*. Exhibited nine paintings at the Society of Artists and nineteen at the R.A.

HOLL, FRANK (1845–88), won a Gold Medal at the Academy School in 1863 and began to exhibit the following year. In 1868 he had his first success with 'The Lord Gave and the Lord Hath Taken Away'. 'No Tidings from the Sea' was bought by Queen Victoria in 1870. 'Newgate – Committed for Trial' was exhibited at the R.A. in 1878. Thereafter most of Holl's work was in portraiture, chiefly of political figures.

HOPLEY, EDWARD WILLIAM JOHN (1816–69), was a student of medicine who turned to painting allegorical and fantastic subjects such as 'Psyche' at the R.A. in 1951 and in 1959 'The Birth of a Pyramid', which was the result of much archaeological research. He also invented a trigonometrical system of facial measurement for artists. He lived in Lewes. How he came to be in India during the Mutiny I do not know.

HORSLEY, JOHN CALLCOTT, RA (1817–1903), brother-in-law of the engineer Brunel, began by painting historical subjects, then turned to 'scenes of flirtation in the countryside'. Joined the Cranbrook Colony in Kent. A keen musician, he was a friend of Mendelssohn.

HOUGHTON, ARTHUR BOYD (1836–75), first became known as an illustrator of *The Arabian Nights* and *Don Quixote* and drawings for *The Graphic*. Later he turned to contemporary *genre* and scenes of domestic life.

HUGHES, ARTHUR (1832–1915), was born in London and studied under Alfred Stevens at the School of Design in Somerset House before entering the R.A. Schools in 1847. He first exhibited at the Academy in 1849, and exhibited his first Pre-Raphaelite painting, 'Ophelia' in 1852, the year in which he met Millais. Inspired by Millais's paintings of lovers' meetings he produced the famous Pre-Raphaelite paintings 'April Love' (1856), 'The Long Engagement' (1854–9)

and 'Home from Sea'. He married in 1855 and had five children. In later life he illustrated books by George Macdonald and Christina Rossetti.

HUNT, CHARLES (1803–77), painter of contemporary *genre* and historical subjects. Exhibited 1862–73 at the R.A.

HUNT, WILLIAM HOLMAN (1827–1910), son of a warehouse manager in London, became a student at the R.A. Schools in 1844, and exhibited at the R.A. in 1846. He became friendly with Millais in 1844 and later with Rossetti, forming the Pre-Raphaelite Brotherhood in 1848. 'The Hireling Shepherd' (1852) was the first of his paintings to develop his style of symbolic realism. 'The Awakening Conscience', first exhibited in 1854, was intended as a companion picture to 'The Light of the World', 1853.

Hunt then worked in Egypt for two years. His infatuation with his model, Annie Miller, ended in 1859, and he married Fanny Waugh who died in 1866. He wanted to marry her sister Edith, but had to do so in France, as marriage to a deceased wife's sister was then illegal in England. After staying for some time in Jerusalem he returned to London in 1878. His later works included 'The Lady of Shalott' (completed in 1905) and 'May Morning on Magdalen Tower' (1888–91). He was the intellectual leader of the Pre-Raphaelites, wrote a series of articles on the Brotherhood in 1886 and his *Memoirs* in 1905.

KNIGHT, WILLIAM HENRY (1823–63), abandoned a career as a solicitor to become a painter, and entered the R.A. Schools in 1845. He soon turned from portraiture to *genre* paintings of village life, usually with a number of children in them. Most of his paintings are small, but show a considerable talent for grouping, individual characterization, and delicate handling of colour.

LANDSEER, SIR EDWIN HENRY, RA (1802–73), entered the R.A. Schools at age of fourteen, and studied dissection of animals and anatomy. Became Academician in 1831, after visit to the Highlands. Queen Victoria admired his work, and commissioned him to paint her dogs. Knighted in 1850. His best-known works are 'Dignity and Impudence' (1839), 'The Stag at Bay' (1846) and 'The Monarch of the Glen' (1851).

LOBLEY, JAMES (1828–88), was the son of a currier in Hull who moved in the eighteen-forties to Leeds where he worked in the School of Design connected

with the Mechanics Institute. Later he set up a studio in Bradford, worked for a time on sculpture, and eventually turned to painting. He exhibited fifteen paintings at the R.A., mostly sent from an address in Brighouse. He became acquainted with Ruskin and with several Bradford industrialists who patronized the arts.

MARTINEAU, ROBERT BRAITHWAITE (1826–69), after studying law, entered the Royal Academy Schools and became a pupil of Holman Hunt, with whom he shared a studio for a number of years. He first exhibited at the Academy in 1852 with the charming 'Kit's Writing Lesson', then followed this with *genre* and historical subjects. 'The Last Day in the Old Home' was shown at the International Exhibition of 1862.

MERRITT, ANNA LEA (1844–1930), was born in Philadelphia and came with her family to England in 1866. She taught herself to paint, taking the *Art Journal* as 'her chief art stimulus'. Her family travelled round Europe between 1866 and 1870, and she had her first studio in Dresden in 1869. Having moved to Paris, she was allowed to enter Cogniet's studio as a student, but the outbreak of the Franco–Prussian war drove her to London. She exhibited a portrait at the R.A. in 1871 and exhibited a number of portraits and subject paintings thereafter. In 1877 she married Henry Merritt, a critic and picture restorer, who died within a year.

MILLAIS, SIR JOHN EVERETT, PRA (1829–96), belonged to an old Jersey family. He came to London in 1838 and studied at the R.A. Schools from 1840. His first exhibit at the Academy was 'Pizarro Seizing the Inca of Peru' (1846). He became friendly with his fellow student Holman Hunt, and in 1848 helped to form the Pre-Raphaelite Brotherhood. His first Pre-Raphaelite painting, 'Isabella' (1848–9), was well received, but 'Christ in the Carpenter's Shop' (1849–50) drew hostile criticism. 'A Huguenot' (1852) achieved great popularity. He was elected ARA in 1853, in which year he visited Scotland with Ruskin and fell in love with Ruskin's wife Effie, whom he married in 1855. From this year on he illustrated many books, including novels by Trollope and Tennyson's poems. In 1863 he exhibited 'My First Sermon' and in 1870 'The Boyhood of Raleigh'. He painted a number of portraits of eminent people in the 'seventies and 'eighties, and became President of the Academy in 1896, having been the first painter to be made a baronet in 1885.

MIDWOOD, WILLIAM HENRY (fl. 1867–71), a little-known *genre* painter

of domestic scenes, who exhibited two paintings at the Society of Artists.

NICHOLLS, CHARLES WYNNE, RHA (1831–1903), born in Dublin, painted *genre*, historical subjects and landscapes. Exhibited at the R.A. 1866–81.

O'NEIL, HENRY NELSON (1817–1880), was born in St Petersburg and was a fellow-student with Alfred Elmore, whom he accompanied to Italy. He was one of the young painters who formed 'The Clique', a small group including Augustus Egg, Richard Dadd and Frith whose aim was to revitalize the traditionalism of the Royal Academy. O'Neil was primarily a history painter, but by far his greater success was with 'Eastward Ho'.

O'NEILL, GEORGE BERNARD (1828–1917), not to be confused with Henry Nelson O'Neil, ARA, was born in Dublin but came to live in the Cranbrook Colony in Kent, where he joined the group of painters including Webster and F. D. Hardy. He exhibited 'The Foundling' at the Academy in 1852, and many other *genre* paintings of rural and village scenes during the 'sixties and 'seventies. His paintings fetched good prices and he was able to keep up a house in Kensington as well as Cranbrook. He and his family were close friends of the Horsleys.

ORCHARDSON, SIR WILLIAM QUILLER, RA (1832–1910), Scottish painter who came to London in 1862 and exhibited at the R.A. from 1863. Specialized in psychological dramas of upper-class life, such as 'Mariage de Convenance' (1883). Later became a fashionable portrait painter.

PERUGINI, CHARLES EDWARD (1839–1918), was born in Naples and came to London in 1863. He exhibited at the R.A. and elsewhere from 1863. He married Kate, daughter of Charles Dickens, who also became a painter, exhibiting a painting entitled 'Little Nell' at the Academy.

POOLE, PAUL FALCONER, RA, RI (1807–79), was born in Bristol, the son of a grocer, and was self-taught as an artist. He became friendly with the wife of Francis Danby, the Bristol painter, and Danby eloped to Geneva with Poole's wife. Poole married Danby's widow after the death of her husband in 1861. Poole exhibited at the R.A. from 1830 to 1879. He became ARA in 1846 and RA in 1861. He is chiefly known for his historical paintings, especially 'Solomon Eagle Exhorting the People to Repentence during the Plague of London' (1843).

[153]

BIOGRAPHICAL NOTES

RANKLEY, ALFRED (1819–72), studied at the R.A. Schools and exhibited at the Academy between 1841 and 1871 and also at the R.B.A. He painted historical subjects and scenes from Scott, but his domestic scenes, such as 'The Lonely Hearth' and 'Home Revisited' (1854) have the same simple emotional appeal as 'Old Schoolfellows'.

REDGRAVE, RICHARD, RA (1804–88), *genre* and landscape painter who entered the R.A. Schools in 1826. In the eighteen-forties turned to contemporary subjects especially paintings of underprivileged women, e.g. 'The Poor Teacher' (1843), 'The Seamstress' (1846) and 'Fashion's Slaves' (1847). Became the first Keeper of Paintings at the South Kensington Museum and Inspector of the Queen's pictures. Co-author with his brother of *A Century of Painting*.

RIVIERE, BRITON, RA, RE (1840–1920), successor to Landseer as the outstanding animal painter. Elected RA 1880 and exhibited at the R.A. from 1858. Painted several historical and biblical scenes incorporating lions, birds and dogs.

RIVIERE, HUGH GOLDWIN, RA (1869–1956), son of Briton Riviere. Studied at R.A. Schools and exhibited thirty-two paintings at the R.A. 1893–1904.

ROBERTS, EDWIN THOMAS (1840–1917), was the son of Thomas Edward Roberts, and, like him, was largely a painter of *genre*. He exhibited forty-six paintings at the Society of Artists, from 1862 to 1886, and two at the R.A. in 1882 and 1884.

ROBERTS, THOMAS EDWARD (1820–1901), was a London painter of *genre*, portraits and historical subjects, who exhibited from 1850 to 1901 at the Royal Academy and a vast number of paintings at the Society of Artists. Despite this industrious output he seems to have received little recognition and in 1859 showed a painting entitled 'The Opinion of the Press', depicting a young artist much discouraged by reading an unfavourable review.

ROSSITER, CHARLES (1827–*c.*1890), painter of *genre*, well known for 'To Brighton and Back for 3/6' (1859).

SMALLFIELD, FREDERICK, ARWS (1829–1915), *genre* painter and watercolourist. Exhibited at R.A., 1849–86. Painted some flower pieces.

BIOGRAPHICAL NOTES

SMITH, GEORGE (1829–1901), studied at the R.A. Schools and under the Academician Charles West Cope. He painted domestic scenes, in the tradition of Thomas Webster and F. D. Hardy, and specialized in studies of children or of women at work in shops, or lacemaking or selling fruit. He exhibited at the R.A. between 1848 and 1887.

SOLOMON, ABRAHAM, ARA (1824–62), elder brother of Rebecca and Simeon, both painters. Studied at the R.A. Schools and exhibited at the R.A. 1841–62. Two railways' subjects, 'First Class – the Meeting' and 'Second Class – the Parting' were very popular, as was 'Waiting for the Verdict' (1857) and 'The Aquittal' (1859). He died from heart failure on the day that the R.A. elected him ARA.

STANHOPE, JOHN RODDAM SPENCER (1829–1908), was educated at Rugby and Christ Church, Oxford, and in 1850 studied under G. F. Watts, with whom he visited Italy in 1853. He became a life-long friend of Burne-Jones, whose influence can be seen in his work. He married in 1859 and exhibited for the first time at the Academy in 1859. Because of ill-health he went to live in Florence, where he died.

STUART-WORTLEY, ARCHIBALD ('ARCHIE') (1849–1905), was a younger son of the first Earl of Wharncliffe. One of his brothers married Sir John Millais's daughter, Alice. 'Archie', as everyone called him, came to stay with Millais in 1874 when 'his interests seemed to be centred in guns and sketch books'. Millais encouraged his interest in painting and, as Archie wrote later: 'I learnt more from him in a few short weeks than from all the other masters who directed or misdirected my artistic studies put together.' He went on to become a successful portrait painter, praised by Ruskin, with several paintings exhibited in the R.A., including a portrait of W. G. Grace, now in Lord's Cricket Museum.

TISSOT, JAMES JACQUES JOSEPH (1836–1902), was a French artist who came to London in 1871 and became a very successful painter of scenes of English Society, especially those with riverside settings. His favourite model was his mistress, Mrs Newton, who appears in many of his paintings, of which the chief are 'Too Early' (1873), 'The Last Evening' (1873), 'The Ball on Shipboard' (c.1874). After Mrs Newton's death he returned to France and concentrated on illustrations for a Life of Christ.

[155]

WALKER, FREDERICK (1840–75), the son of a London jeweller, studied at Leigh's Academy and the R.A. Schools. He began as a draughtsman for wood-engravers, and as a magazine illustrator. He re-drew illustrations for Thackeray, and became successful as a watercolourist, exhibiting at the Old Water Colour Society. He only exhibited eight oil paintings at the R.A., beginning with 'The Lost Path' in 1863 and 'Spring', now in the Tate Gallery. He became ARA in 1871 and died of consumption four years later.

WEBSTER, THOMAS (1800–86), son of a member of the Royal Household at Windsor, sang in the Chapel Royal Choir, and entered the R.A. Schools at the relatively late age of twenty-one. He was elected as ARA in 1840, and continued to exhibit his characteristic 'cabinet' paintings of domestic life, especially children at school and at play, into the eighteen-seventies. He was a prominent member of the Cranbrook Colony, sharing a studio with F. D. Hardy and collaborating with G. B. O'Neill. In his later years he became a familiar figure, in Cranbrook, driving himself in a bath-chair drawn by a donkey.

WINDUS, WILLIAM LINDSAY (1822–1907), was a Liverpool man who became a pupil of the historical painter, William Daniels, under whose influence he painted several historical subjects. He was elected a member of the Liverpool Academy in 1848. Two years later he visited London, where he saw Millais's 'Christ in the House of his Parents', and became an adherent of the Pre-Raphaelites. In 1856 he painted his first picture in the Pre-Raphaelite manner, 'Burd Helen', illustrating the Scottish ballad of Burd Helen, who followed her cruel lover, bore his child, and eventually married him. The painting was 'skied' in the Academy, but Rossetti noticed it and although that year's Academy included Arthur Hughes's 'Eve of St Agnes' Ruskin considered Windus's painting 'the finest thing of all in the place'. Windus seems to have suffered from depressions and self-doubt, as was instanced by his lack of belief in 'Too Late', which took him nearly two years to finish. After Ruskin's severe comments on that picture he virtually abandoned painting. He never exhibited after 1859.

YEAMES, WILLIAM FREDERICK, RA (1835–1918), was born in Southern Russia, the son of a British consul. He studied in Dresden, before coming in 1848 to London, where he was a pupil of G. Scharf. He also studied in Rome and Florence between 1852 and 1858. In 1859 he exhibited at the R.A., and he became an ARA in 1866. His chief interest was in historical scenes of the Tudor and

Cromwellian periods, as exemplified by his painting of the death of Amy Robsart (1877), a grisly picture of her lying at the foot of the stairs in Cumnor Hall, with two men of sinister mien gazing down at her motionless corpse. His claim to fame, however, rests on 'And when did you last see your Father' (1878), which is now in the Walker Art Gallery, Liverpool. Yeames became a member of the St John's Wood Clique, and he was appointed Librarian of the Royal Academy.

Index